THE THAMES AND HUDSON MANUALS
GENERAL EDITOR: W. S. TAYLOR

Screen Printing

GW00566762

Tim Mara

The Thames and Hudson
Manual of
Screen Printing

with 136 illustrations, in colour and black and white

Thames and Hudson

Printed and bound
in Great Britain by
Fakenham Press Limited,
Fakenham, Norfolk

Contents

Acknowledgments

There are a number of people, not mentioned elsewhere, who have helped me in the production of this book and whom I would like to thank: W. S. Taylor, general editor of the series; Stephen England of Thames and Hudson; Belinda Mara, my wife, who typed the manuscript; Chris Plowman and Bob Tipper of the Royal College of Art; Terry Gravett of Brighton Polytechnic; Peter Jones of the National College of Art and Design, Dublin; Colin Blanchard of the North-East London Polytechnic; Chris Prater and Doug Corker of Kelpra Studio Ltd, London; Chris Betambeau of Advanced Graphics, London; Mr Eddie Bailey of Pronk, Davis & Rusby Ltd; Mr Kilvert of Omega Advertising on behalf of E. T. Marler Ltd; Liz Underhill of the Tate Gallery, London; Sue Lambert of the Victoria and Albert Museum, London; Alan Cristea of Waddington Graphics, London; Don and Prue of Anderson O'Day, London; The Zurich Silk Bolting Cloth Mfg Co. Ltd, Rüschlikon, Switzerland; Malcolm Thomas of Kissel and Wolf Ltd.

The diagrams in this book are by Tim Mara. The black and white photography unless otherwise stated is by Tim Mara. The cover photograph is by Chris Plowman. Frank Thurston photographed most of the colour plates.

I would also like to thank those artists who have generously given permission for their prints to be reproduced. Acknowledgments are due to the following for permission to reproduce the screen prints on the pages shown: Advanced Graphics (pp 18, 35, 141, 159); Anderson O'Day (p 106); The Abrams Family Collection (p 17); Bradford Art Galleries and Museums (p 70); Gemini, G.E.L. (c) 1974 (pp 35, 142); Tate Gallery (pp 17, 72, 87, 88, 106, 123, 124, 160).

T. M.

1 The history and development of screen printing

A knowledge of the history and development of a process such as screen printing is of more than purely academic value for it is through a knowledge of its past and of how current processes have developed that future innovations may take place.

Screen printing is a relatively new process in the history of printing as a whole, and only during the past 30 years has it blossomed from a hand-operated workshop procedure into a fully-fledged industrial process with tendrils stretching into production areas as diverse as electrical circuit printing and the application of designs to glass bottles.

Screen printing is a stencil process and, as such, its history is two-phased. There is evidence of stencil application that goes back over a thousand years in some cultures (stencils were used by the ancient Egyptians, Romans, Chinese and Japanese for decorating walls, floors, ceilings, pottery and fabrics), yet the application of stencils to stretched fabric for printing in the way that we now know it only dates from the turn of this century.

Packing case stencil letters, which solve the problem of 'island' areas with connecting 'bridges'.

The greatest drawback with stencils has always been the need to find a way of overcoming the problem of tying the isolated areas in the design to the main image. This was traditionally solved by cutting bridging sections into the main stencils which, as the needs of stencil work became more complex, came to represent unwanted crudeness in the design. (Even today lettering stencils for labelling boxes and packaging cases still employ bridges to keep all the parts of each letter in their correct relative position.) A method was needed whereby island areas in the stencil could be maintained in position without transferring the bridge to the final product.

The Japanese are credited with providing the best solution to the problem. They cut two exactly matched paper stencils for each design; a human hair web was then glued across the first stencil to hold all its parts in true position, and the second stencil was subsequently glued in the exactly corresponding position to its hair-supported opposite. In this way the Japanese were able regularly to transfer intricately designed patterns to garments and fabric by dabbing colour through the open stencil areas onto any surface. The human hair support was soon superseded by fine silk threads, and the stencil process remained at this stage for centuries of use.

It was not until the middle of the nineteenth century that stencils were first applied to silk mesh, and towards the end of that century (in which there was an enormous European interest in Japanese culture) the first silkscreen equipment, with some of the aspects now associated with it, arrived. But it was not until 1907 that the first patent was taken out on silkscreen printing in a form that would still be recognized today – that is, with a stretched frame and a squeegee.

During the first world war silkscreen-printed flags, banners and pennants were produced by hand-operated silkscreen equipment.

In America stencil processes flourished in the nineteenth century as they were readily accepted by immigrants who had very little access to any kind of machinery and who were adept at converting and developing processes that they felt might be of some use to them. It was in the USA that the first photographic silkscreen stencil was produced in 1915. From that point onwards silkscreen printing gained a new lease of life.

The textile industry, in particular, picked up on the new process, and in the 1920s and 1930s designers began to work with tracing film for photo-stencils. This created a whole new range of fabric designs that blended perfectly with the mood of the times.

The silkscreen process was seen as a stage between block-printing and industrial textile processes. Artists and designers were commissioned to produce designs for high-quality fabrics that were made in marketable quan-

Japanese stencil.

tities but were not mass-produced. These artists responded to the ability of the tracing film photo process to render the quality of their drawn marks accurately, and so fabric designs were produced that were unique for their time. The adaptability of silkscreen printing for experimentation and innovation ensured its survival in textiles: it has now become a process industry in its own right, using the specially developed rotary screen presses.

While the textile industry was exploiting the abilities of silkscreen printing in the 1930s the conventional side of the process was witnessing the introduction of automatic screen-printing machines capable of turning out printed paper in thousands. Since the 1930s screen printing has steadily developed into all its multifarious directions to become a process that is as capable of serving the home-based craftsman as it does the printer who wants to compete for work against production lithography.

The earliest printers had to use paint but the process began to interest ink manufacturers, and soon inks were developed to keep pace with the process. The early silk-screen printers went to the bolting-cloth manufacturers for their fabrics. These manufacturers produced silk of varying fineness for use in flour milling to sift flour into grades, but they were quick to recognize the new demand and to instigate the research and development which has been as responsible as any aspect of the process for bring-

ing it to the level that it now operates on. The research performed by the bolting-cloth manufacturers led to the development of nylon and polyester monofilament fabrics, which have allowed the screen-printing process to operate in areas requiring a high degree of accuracy. The introduction of synthetic mesh has also led to the dropping of the name 'silkscreen printing' in favour of simply 'screen printing' or 'the screen process'.

As far as screen printing by artists is concerned, it is true to say that many artists have used the process to produce prints since the 1930s and 1940s when they were first introduced to silkscreen printing via the textile industry.

The first examples of silkscreen prints seem largely to imitate drawing and painting techniques, showing little innovation with respect to the medium in its own right. The process was known as serigraphy (drawing in silk) to distinguish it from the industry as a whole. Even now there is still a considerable use of screen printing as a craft process.

The use of screen printing by some artists during the 1950s, who were attracted by its directness, painterliness and vivacity, tended to free the process somewhat. But it was not until the early 1960s that screen printing got its head, when artists such as Paolozzi, Warhol, Rauschenberg, Hamilton, Kitaj and Tilson took an interest in its photographic capabilities in relation to their collage work and began to incorporate it on a large scale on canvas as well as on paper, producing collage photo-stencil images that are still visually influential today.

Currently screen printing as a process is evident in numerous fields: it is widely taught in schools and colleges and is used as a component part of many art and design processes, while artists continue to push it in any direction that it will go – making images that range from brush strokes to photographic colour separations.

2 Workshop layout and equipment maintenance

Most screen-printing workshop/studios are an accumulation of changes and innovations. They depend for their design on needs dictated by the work envisaged and the finances available. It is only in a very rare case that an artist will get the opportunity to plan and set out a fully equipped workshop to an ideal design: it is more common to have to tailor an existing environment to meet, as far as possible, the requirements of a screen-printing studio. This chapter, however, will tend towards describing an ideal workshop in order to include as much relevant and helpful information as possible.

Regardless of the given situation it is extremely important to design or redesign the studio carefully in order to extract the maximum efficiency from it. The layout of the studio should physically mirror the chronology of the screen printmaking process: theoretically a circuit of the process activity should be established in order to allow the artist/printer to start at the mesh degreasing stage and to work right through the process back to the screen cleaning stage without crossing or retracing his own path. The different parts of the process must be kept separate. Clean and dirty activities must not overlap one another as contamination will result, causing endless stencil and printing problems. It is obvious that the type of work performed in a studio is going to go a long way towards dictating the layout. However, in a situation where the screen frames are ready-made, the process inevitably starts at the frame preparation stage.

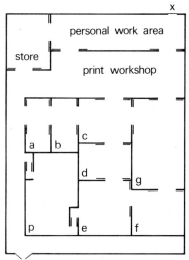

Ideal layout plan for a screen-printing studio: *a* screen preparation; *b* mesh stretching; *c* degreasing and screen cleaning; *d* coating; *e* exposure; *f* stencil washout; *g* stencil mounting and screen storage; *p* general photographic darkroom; *x* fire exit. Note exclusive use of sliding doors to eliminate dust and to conserve space.

STUDIO LAYOUT

The frame preparation room

The frame preparation room is likely to be a very messy one as it houses the tools and equipment for the stripping of obsolete mesh from used screens and the grinding of frame surfaces to achieve maximum mesh adhesion. It should also provide work surfaces and storage space for new frames and for used screens that are to be refurbished.

Dust extraction is essential, whether it is a component part of the grinding tool or is in the form of a room extractor fan. It is also important to wear goggles and a

11

face mask to minimize the risk of breathing in dust or of getting wood or metal particles into the eyes.

The frame preparation room leads into the mesh stretching and screen preparation section.

The screen preparation room

The prepared frames are converted into screens in the screen preparation room. This section houses the mesh stretching and tension measuring equipment, and should also provide storage for the mesh, the adhesives, the newly stretched screens and the various sundries for taping and lacquering the newly stretched screen. Work surfaces must also be provided.

Again good ventilation is important as the mesh adhesives exude solvent fumes while drying.

If the screen then requires priming and degreasing for stencil reception it is taken through to the degreasing and cleaning room.

The degreasing and cleaning room

The degreasing and cleaning area contains a large trough which has a double function: it is used for degreasing screens in readiness for stencil mounting and also for cleaning used screens in readiness for degreasing. The room may also contain a screen washing unit incorporating a pump and a solvent reservoir, used for removing ink deposits on the screen. A used screen will come directly from the printing area to the degreasing and cleaning room and, by the use of solvents and high pressure water pumps, will be rendered into condition for degreasing. This is an extremely messy process so the design of the room must be carefully considered.

The trough should be large enough to take the largest screen and its whole surround should be a cleanable, watertight surface (it is an advantage if the floor is also watertight). The trough should contain a duckboard and should have a drainage outlet large enough to accommodate the decomposing stencil material.

The room will also house the high-pressure water unit and provide storage for solvents, degreasing agents, new mesh, fine abrasives, and screens requiring cleaning and degreasing. A drying cabinet may also be necessary for speeding screens towards stencil coating.

Ventilation is of prime importance in this area as the blend of vapours from solvents, degreasing agents and 'atomized' water is very noxious.

The degreased screen will then either go directly to the stencil mounting area for use with hand-cut or indirect stencils or it will be coated in readiness for direct stencil exposure.

The coating room

The coating room

The coating area is essential only if direct stencils are in use. The room should be as dust-free as possible, which implies that the wall and ceiling surfaces should be smooth and easily cleaned. The lighting should be by gold fluorescent tube, which is quite bright but low in ultra-violet, and the walls can be painted matt pale yellow so that they will reflect practically none of the minute amount of the ultra-violet light that the gold fluorescents emit, thus preserving the sensitivity of the photo-emulsion. The room must contain a smooth working surface if direct/indirect stencils are in use. It is an advantage if there is a refrigerator for storing the photo-emulsions and a dust-free, light-proof drying cabinet for the coated screens (the screens should be dried ink side up). A full range of coating trough sizes should be stocked and these must be fully cleaned after use.

Excessive ventilation in this area will create flying dust particles which will adversely affect the direct emulsion screen coating.

The coated screen is then taken through to the exposure room.

The screen exposure room

Like the coating room, the screen exposure room must be lit with gold fluorescent tubes and the walls must be painted a matt pale yellow or black to absorb as much reflected ultra-violet rays as possible during exposure. As with the coating room or any darkroom area the exposure room must be as dust-free as possible for dust can easily settle between the positive and emulsion, resulting in bad stencils. Ventilation must therefore be carefully controlled in order not to stir up dust particles.

The exposure room houses the light source and the printing-down frame. These must always be kept clean and fully operational. Periodical test exposures should be made to check the strength of the light source and to establish any changes in exposure times. A work surface is useful in the exposure room when laying out the positive onto a direct screen. A cabinet system should be provided for filing positives and a light-proof cabinet must also be available for storing indirect stencils. The levels of temperature and humidity should be maintained in accordance with the stencil film manufacturer's recommendations.

Ultra-violet light is extremely harmful to the eyes and so absorbing goggles must be worn and, better still, the operator should leave the room during exposure. An unsealed light source such as the carbon arc presents another danger: in addition to its ultra-violet light rays a carbon-arc lamp, when lit, emits toxic carbon monoxide,

ozone, nitrogen oxides and metal fumes, which are very detrimental to the lungs and, with frequent exposure, can cause severe pulmonary fibrosis and emphysema. For this reason carbon-arc lamps are not recommended, despite the fact that they do produce an excellent ultra-violet light beam as far as the stencil-making process is concerned. Carbon-arc lamps are outlawed in some countries and presumably legislation will eventually follow in the UK. If, however, a carbon-arc lamp is in use it must be ventilated directly to the outside via a canopy hood. Sealed-beam light sources such as the metal halide lamp are strongly recommended instead.

The exposed screen or indirect stencil material is then taken through to the washout room.

The washout room

The washout room houses the stencil washout sink which, as described in Chapters 6 and 9, can incorporate a back-lit translucent Perspex sheet for monitoring the progress of the stencil.

Warm-water plumbing as well as cold water will be required if certain makes of indirect stencil are in use. A developing tray for indirect stencils and storage facilities for chemicals must be provided. The sink will require a watertight surround and, as in the case of the degreasing room, it would be an advantage if the floor were also waterproof. Gold fluorescent tube lighting is again necessary in this area, to protect the stencil detail.

The stencil washout process is a clean and gentle one so, while air extraction is not required for the removal of solvents and water spray to the same extent as in the degreasing room, it is necessary for removing any fumes from the hydrogen peroxide which is used for developing indirect stencils. The hydrogen peroxide solution should be kept covered when not in use. Ventilation, in any case, always makes for comfortable working conditions.

The washout room should also contain a cabinet for horizontally drying the processed screens. It is best to use warm circulating air for drying the processed screen.

The processed screens or indirect stencils are next taken through to the stencil finishing room.

The stencil finishing room

In addition to the retouching of the processed direct photo-stencil screens the stencil finishing room is used for mounting indirect hand-cut and photo stencils onto the screen, and this room must be kept clean. It should contain a large table-top light box to facilitate stencil retouching and a work surface with build-up pads for indirect stencil adhesion. Added to this a vertical storage

system should be provided to contain the fully processed screens, which should be stacked independently from one another in order to avoid any mesh or stencil damage.

The retouching process involves spotting out any holes in the screen stencil and filling in the open areas around the stencil. Indirect stencils are screen mounted via clean newsprint so therefore screen fillers, all sundry items and newsprint must also be stored in the stencil finishing room. There should be a fan for drying indirect stencils and retouched filler work. This room can also be used in conjunction with the degreasing room for the preparation of direct manual stencils.

The stencil finishing room is the last stage before the actual printing.

All the areas that have been described so far come under the general heading of the stencil-making department, but in addition there are some points that should be observed with regard to the functioning of this section as a whole.

Temperature and humidity control. Apart from promoting comfortable working conditions and therefore greater alertness it is obviously an advantage to have controlled temperature and humidity throughout the stencil-making areas to ensure the safe storage of adhesives, emulsions and photo-sensitive films. Very low temperatures have an adverse effect on drying, exposure and adhesion times, and conversely very high temperatures will cause extra hardening of the stencil emulsion, resulting in washout difficulties. Indirect photo stencil film is particularly sensitive to temperature and humidity and therefore should be stored according to the manufacturer's instructions even if the rest of the workshop is not climatically controlled.

Bio-degradable products. Photo emulsions that were previously sensitized with ammonium and potassium bichromates are now also available in chromium-free diazo-based compounds. It is advisable to use these chromium-free emulsions, firstly for personal reasons (bichromates are harmful to the skin) and secondly for ecological reasons as chromium is not bio-degradable. In some countries it is illegal to allow chromium-containing products to enter the drainage system as they have a harmful effect on the enzymes in the filter beds. In these cases wastage collection services are used. The de-coating products that are used to remove bichromatic sensitized emulsions are also non-bio-degradable, while those used for diazo emulsions are bio-degradable. There is no legislation in the UK (at the time of writing) with regard to bichromates and de-coating agents but it is anticipated that directives will eventually be given. In the meantime it is recommended that diazo-sensitized emulsions are used with the appropriate de-coating agents. If bichro-

mate emulsions are in use then all due safety precautions must be taken.

Drying cabinets and doors. The drying cabinets used for the three drying stages in direct photo screen preparation, which are the post-degreasing, the post-coating and the post-washout drying cabinets, can be double-ended and can actually span two rooms. For instance, a degreased screen can be inserted into the drying cabinet via the cabinet doors in the degreasing room and when dry can be extracted via the cabinet doors in the coating room. The same procedure can be followed between the coating room and the exposure room and again between the washout room and the stencil finishing room. This system sounds luxuriously ideal but it does cut down on dust, unwanted light and other contamination.

Sliding doors between rooms represent an advantage in as much as they are space savers and they do not stir up as much dust as hinged doors.

The print workshop

The actual print workshop area is best regarded as a completely separate entity from the stencil-making department, because in practice, printing is a very different process from stencil making, and any overlap between the two would be detrimental to both.

The print workshop houses the screen presses, the drying racks and the paper feeding tables, and should also provide storage for the squeegees, the inks, the solvents, paper and all other necessary sundries. The screen-printing press is the key piece of equipment in the whole screen-printing process and so it must be looked after carefully: movable parts must be oiled and checked regularly and all adjustments to parts should be made according to the manufacturer's instructions. The machine should be kept clean and must never be used as a work surface since scratches and cuts on the press bed will not only accumulate dirt and spoil the underside of prints but will also undermine the function of the vacuum. It is important to clean the press bed after each printing in order to remove any dust, unwanted ink or tape. Screens must never be cleaned directly onto the press bed as the vacuum will eventually suck solvents inside the press and even into the vacuum unit itself and in so doing destroy parts of the machine. Added to this the solvents can re-emerge through the underside of the paper during subsequent printing.

For storage, squeegees can be hung up by screw eyes fixed into one end of the blade holder.

The ink section of the print room must provide a storage facility for the inks and also a surface for ink mixing. A variety of containers are used for ink mixing, ranging from tins to wax-coated paper cartons. Waste ink

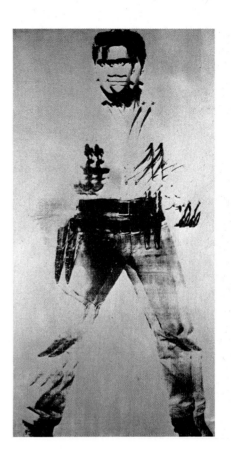

Right: Andy Warhol, *Triple Elvis*, 1962, 208·3 × 106·7 cm.
Screen printed with silver ink onto canvas using one screen
photo stencil, which was moved and printed three times to
create the multiple effect.

Below: Richard Hamilton, *Adonis in Y Fronts*, 1962–3,
61·1 × 81·6 cm on J. Green paper. Published by the artist in
conjunction with the Petersburg Press, London, in an
edition of 40. Screen printed using hand-cut, Kodatrace
and photographic stencils. The head and shoulders are the
original halftone screening from the magazine source
material. The spring and handles are printed from a
Kodatrace stencil using a separate black. One gold, two
silvers, three greys and a white (for the actual Y Fronts)
have been printed. 12 printings, printed by Kelpra Studio
Ltd, London.

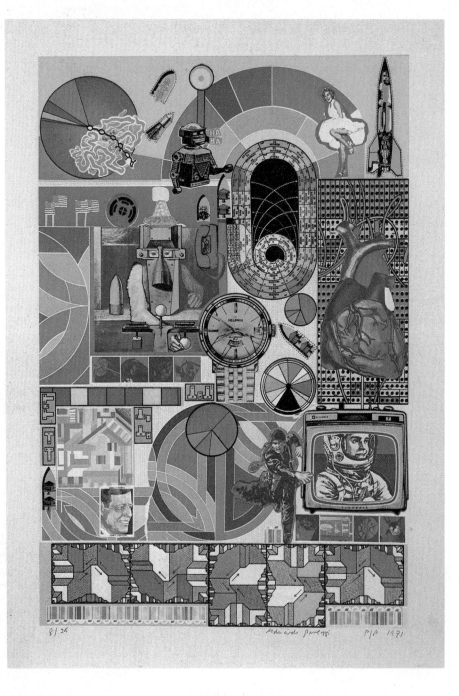

Eduardo Paolozzi, *B.A.S.H.*, 1971, 74 × 50 cm. Published by the artist in an edition of 3,000. Screen printed from an original collage using photographic, hand–cut and letratone stencils. 15 printings plus forme-cut collaged elements. Printed by Advanced Graphics, London. Reproduced by kind permission of the artist.

must not be poured into the drainage system. Reusable ink mixes should be sealed and stored in a cabinet system that reflects the colour ranges that those ink mixtures are closest to. The ink storage cupboard should be fire-proof.

Used rags must be kept in metallic fire-proof containers, as should any solvents that are not actually in use. Only very limited quantities of solvents, especially screenwash, should be stored in the studio.

The print workshop should be kept scrupulously clean and all working surfaces including paper feeding tables should preferably be of the laminated Formica type. The workshop must be well ventilated in order to remove all noxious solvent fumes. As the solvent vapours are heavy, it is advisable to install the air extractor at a low level. It is also extremely important to have control over the temperature and humidity as constant fluctuations will bring about changes in the printing paper size and cause insurmountable registration difficulties.

General darkroom

It is likely that the type of screen-printing studio that is envisaged here would incorporate a general darkroom as well as a stencil process darkroom. The general darkroom should either contain a copy camera room or incorporate a camera enlarger. It should also have a standard enlarger for 35 mm or 120 mm film and all the dishes, sinks and drying systems that go with photographic printing. It should be well ventilated and it must have the appropriate safe lights for whatever photographic material is in use. Dust must be avoided as far as possible. Ideally this darkroom could border on the screen process darkroom and a light box should be provided for retouching positives. Entrances and exits from the darkroom must be in the form of a light trap.

General store room

A general store room is always useful for storing paper, chemicals, fillers, gums, tapes and all sundry materials. Plans chests are indispensable in the studio for storing prints and general ephemera. Temperature and humidity should be controlled in order to preserve whatever materials may be in the store.

Personal working area

An artist is going to need a personal working area, which should, ideally, be remote from the printing workshop and stencil department – if not in terms of its geography at least in terms of its character. This environment will not conform to any pattern as it is likely to reflect the predilections of its user.

3 Frames

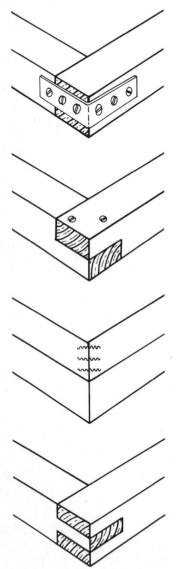

Screen frame joints *(top to bottom)*: butt; overlap; mitre; mortise and tenon.

The screen is essentially a very simple piece of equipment that can be produced to meet the requirements·at any level of screen printing.

At one end of the scale a screen can be satisfactorily made from four lengths of wood, a sheet of organdie and some wire staples, while at the other extreme special metal sections, meshes and adhesives are required.

Wood will shrink, expand and consequently warp in order to meet the changes in atmosphere whereas the more highly priced metal, being stronger, is more stable and, certainly in commercial circumstances, represents a more economical investment. Wood, although less stable, is still the most commonly used material for screen production in both art colleges and print workshops.

As the quality of the screen is going to have a considerable influence over registration and ease of printing it must be produced to stringent specifications. In short, it must be perfectly flat and the mesh must be tightly and evenly stretched.

The size of screen is determined by both the size of the job and the size of the press in use. It is also worth taking the manufactured mesh width into consideration in order to avoid unnecessary off-cut wastage. Most studios or workshops will work with a range of screen sizes that are capable of dealing with any job that the studio is likely to entail.

WOODEN FRAMES

It is important that the wood chosen for the frame is carefully considered. It would be pointless to use unseasoned pine as it would undoubtedly warp very quickly. The better woods to use are cedar, beech, and pirana pine. The sectional size of the wood must be chosen to provide dimensional strength for the overall size of the frame (see table on p. 21).

The inner measurements of the screen frame should be at least 25 cm (10 in.) greater in both dimensions than the planned image size, and if possible 35 cm (14 in.) greater in the squeegee action direction. The wood must be securely jointed as it is at the joints that weaknesses are most likely to occur. The strongest practical joint is the mortise and tenon. Factory-made screens may have a dovetail joint but this is beyond the capabilities of most

people. Simpler yet quite effective joints are the overlap joint and the mitre joint (which must be reinforced with corrugated fasteners). On the smaller screen frames it is possible to get away with butt joints strengthened by screwed corner brackets.

The joints must be glued during assembly and the whole frame clamped to a flat surface to ensure that the finished frame will be perfectly flat. These joints may be screwed for extra rigidity. It is important that the adhesive is resistant, as far as possible, to both water and solvent.

The contact adhesives and the two-component adhesives used for mesh/frame bonding and discussed on p. 40 are very suitable for this purpose. Resin W wood glue is an adequate adhesive provided that the less powerful solvents are in use, as usually in the case of a hand press/ table top set-up.

The corners and the outer edges of the under frame should be rounded off by planing or sanding in order to reduce the possibilities of splinters or jagged wood damaging the mesh during stretching. The frame is finally coated with a water- and solvent-resistant lacquer such as shellac, polyurethane varnish or even a dilute compound of the two-part adhesive.

If the frame is carefully made with good wood it will last for years and consequently justify the use of the very best meshes. (Screen mesh is dealt with in Chapter 4.)

Wooden screen frame with mortise and tenon joint.

METAL FRAMES

Metal frames are made from tubular steel and aluminium and are usually rectangular or square in section – although in industry, especially textiles, triangular sections are used. These, however, cannot be fitted to most screen-printing presses.

The walls of the tubular metal and the section size will vary according to the size of the screen. The aluminium wall thickness must be greater than that used for a steel frame of the same size, and the sectional dimensions must also be greater in the larger frame sizes. The following table will assist in choosing the appropriate materials for frame making:

Cross-sections of metal types used in screen frame manufacture.

	Image printing area in cm	Suggested inner frame size in cm	Plane wood section in cm	Steel section in cm	Steel wall thickness in mm	Aluminium section in cm	Aluminium wall thickness in mm
A0	84 × 118	109 × 153	10·0 × 7·5	4 × 5	2	4 × 6	3
A1	59 × 84	84 × 119	10·0 × 7·5	4 × 4	2	4 × 5	3
A2	42 × 59	67 × 94	7·5 × 5	4 × 4	1·75	4 × 4	2·5
A3	30 × 42	55 × 77	7·5 × 5	3 × 3	1·75	3 × 3	2·5

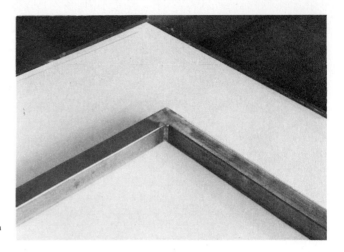

Prepared welded corner of metal screen frame.

The care that is taken in the preparation of wooden frames is equally appropriate for metal ones. The corners must be carefully welded to ensure both maximum rigidity and frame flatness. The weld should be leak-free in order to prevent any corrosive agents, such as water or caustic soda, from entering the inner metal tube during degreasing or washout (caustic soda will even have a corrosive effect on aluminium).

The outer surface of the steel frame must be coated with a tough solvent-resistant lacquer which will not be easily penetrated or chipped away during the constant fixing and unfixing of the frame to the screen. Factory-made metal frames are often galvanized for anti-corrosive protection.

As with wooden frames, the bottom edges and sharp corners must be rounded with a power grinder in order to ensure the best tear-free reception for the screen mesh.

Both wooden and metal frames are available ready-made, pre-stretched or not, from most screen process suppliers.

SELF-STRETCHING FRAMES

The frames just described are known as rigid frames. There is another type of frame known as the self stretching frame which compared with the rigid frame is a rather complicated device. Due to the expense it is generally in use where only a small number of screens are stocked and where the purchase of specialist stretching equipment is unjustifiable. This screen frame is a rigid version of the roller bar stretching frame described in Chapter 5; it can be used as a master frame for the adhesion of mesh to smaller frames, although it would be pointless to buy one specially for this purpose as there is already more economical and versatile equipment on the market.

4 The mesh

The fact that the earliest and indeed some of the most intricate and successful screen stencils were supported by human hair should indicate that the mesh possibilities for screen printing are extremely diverse.

Human hair was superseded by silk strands and eventually (after centuries of dormancy) by woven silk fabric, which became the most commonly used screen mesh until the 1950s and 1960s. Since then the screen process industry has developed at an extraordinary pace and in many varied directions. The manufacture of synthetic mesh has both kept pace with this development and in some instances has pushed the process into new directions. The industry is nothing if not flexible.

It is therefore worth noting that, besides the normal run of screen-printing fabrics, there are countless other fabrics and materials that will support a stencil and which, relative to their inherent manufactured qualities, will provide a range of differing results. Some examples are lace, synthetic net curtaining, fruit sacks, gauze bandaging, hair nets, nylon stockings, wire gauze, and perforated zinc. It does not take much imagination to recognize the potential quality differences resulting from the use of any of these as a stencil support.

MULTIFILAMENT AND MONOFILAMENT THREADS

Conventional screen-printing fabrics fall into two main categories – multifilament and monofilament, terms which refer to the thread structure of the weave. The multifilament thread is made up of several thin filaments twisted together to form the one thread, whereas monofilament thread is what its name implies – a one-filament thread.

Monofilament threads are found only among the synthetic meshes and, in almost all cases are more advantageous to use than multifilament. A glance at the two photographs (p. 24) will make the difference clear. The multifilament weave appears bulky and unstructured when compared with the sleekness and regularity of the monofilament weave. The relative bulkiness in the multifilament mesh prevents it from being woven to the same fineness as the monofilament, thus precluding its

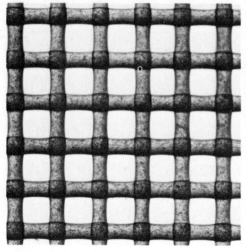

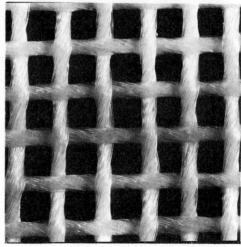

Monofilament screen-printing mesh welded at its intersections (photograph courtesy of Zurich Bolting Cloth Mfg Co. Ltd).

Multifilament screen-printing mesh (photograph courtesy of Zurich Bolting Cloth Mfg Co. Ltd).

use in very fine detail work. It allows ink to collect in its weave more readily, causing both discoloration during subsequent printing and cleaning difficulties that result in the residual presence of 'ghost images' on the screen mesh. It is also far less resistant to abrasion than mono-filament weave as the composite thin strands can be progressively worn through. Multifilament weave does, however, have the advantage that its thread structure will allow much better indirect stencil adhesion, which could be sufficient reason to make it a better choice of mesh for printing coarser detail.

The synthetic monofilament thread is welded at its joins and provides a much more controlled print at a higher level of quality. It is more fully described later in the chapter (see p. 26).

COTTON ORGANDIE

The cheapest mesh among the conventional screen-printing fabrics is cotton organdie, which can be bought from many material stores. It is used for very basic stencil work, usually at the craft end of screen printing. Organdie is a relatively coarse printing fabric and, being organic, is multifilament. It is not manufactured to a consistent quality or weave and, as it is neither strong nor elastic, care must be exercised during stretching. When stretched it should be lightly wiped with warm water to prime it for stencil reception. It should not be washed with water again as this releases the size from the organdie and creates slackness; owing to the non-elasticity of organdie, slackness will inevitably occur during printing, rendering the screen useless. This, however, is not such a great problem because organdie is virtually a disposable material because of its low cost.

SILK

Silk was for so long the traditional printing fabric in screen printing that the process is still persistently referred to as silkscreen printing, now something of a misnomer as, thanks to screen mesh research and development, the use of silk is now the exception rather than the rule.

Silk, being organic, is a multifilament mesh with all the inherent disadvantages plus one or two more. Being an organic product it is more susceptible to moisture absorption, which causes variable and uncontrolled degrees of slackness that effect registration during printing, and as it is less resistant to chemicals than synthetic mesh it must only be degreased with ordinary non-alkaline domestic washing agents. Only gelatin photo stencils should be used with silk as they can be removed with enzymes, as opposed to oxidizing agents such as sodium hypochloride which would attack the fabric.

Despite its disadvantages, silk is nevertheless a good and serviceable screen fabric up to the point where the stencil detail is not too fine and a degree of registration overlap is acceptable. Careful and sympathetic processing will produce the best results from silk, as can be borne out by the numerous examples of good-quality silk screen printing that was produced before the arrival of synthetic mesh.

The grading of silk

Silk is sold in a wide variety of weave fineness and thread thickness. In the definition of the different silk meshes the thread thickness is expressed as either s, x, or xx, meaning respectively standard, medium and heavy-duty mesh. Standard and medium mesh are used in the normal run of print making; heavy-duty is used for tough jobs and heavy ink deposits.

The fineness of weave is expressed numerically, and relates to the number of threads woven into each linear centimetre or inch (see p. 28–29 for full table). A no. 6 mesh is very coarse, and having only 29 threads per centimetre would not support a fine halftone dot stencil but would instead cause the finest dots to fall through the mesh openings. Consequently a finer mesh would be required. The relation of mesh count to halftone count is discussed in Chapter 8, pp. 89–90.

A coarse mesh will also give a serrated edge to stencil shapes. The smoothness of the shape edge is proportionate to the fineness of the mesh. In addition to defining the thread thickness the mesh description s, x or xx also indicates the likely printed thickness of the ink deposit. For example, a mesh numbered $16s$ will be far thinner in cross-section than a mesh $16xx$. The thickness

of the mesh ensures that a much heavier deposit of ink is made by the heavy-duty mesh than by the standard mesh. The heavy-duty fabric will also affect the quality of the halftone stencil by imposing its mesh structure on the detail whereas the standard thread mesh, having the same number of thread intersections per square centimetre, while accommodating the halftone dot, will allow it sufficient room to establish its own identity. Therefore, in the case of a fine-detail job running into thousands, a number of standard mesh repeat stencils may be preferable to one heavy-duty stencil. The printed numbers involved are so high that this problem is not likely to affect the artist. It is important to assess both the work and the workshop circumstances in determining which is the optimum mesh to use for screens. Most workshops carry a selection of different quality screens to cover a wide range of possible jobs.

Under the microscope silk reveals itself to have tiny hairs emanating from the thread. These represent an advantage in that they will allow the silk to accommodate indirect stencils more readily, and a disadvantage in that they will very quickly collect ink particles and so lead to ink blockage during printing.

Silk must be thoroughly moistened before it is stretched in order both to increase its elasticity and to allow it to return to maximum tautness as it dries. It should be stretched wet to approximately 2 per cent elongation (percentage elongation is discussed in Chapter 5). It does not require even a mild abrasion for stencil reception but it will require degreasing.

SYNTHETIC MESH
(NYLON AND POLYESTER)

Synthetic nylon and polyester meshes are manufactured in both multifilament and monofilament weave although multifilament is not very common because it incorporates many of the disadvantages that are found in organic fabrics.

Multifilament polyester mesh can be used with indirect stencils for less detailed work. Monofilament synthetic meshes, on the other hand, are highly developed and sufficiently varied to cope with the whole spectrum of screen-printing work.

The grading system is different from silk in that the thread thickness is graded s (light quality), M (medium), T (heavy), or HD (extra heavy-duty). The mesh number refers to the thread count per inch or centimetre of the mesh (at the time of writing the grading is still in transition to metric specification) and this can prove confusing unless the system is properly understood. For example, a 260T is a heavy mesh of 260 threads per inch whereas a

200T is a heavy mesh with 200 threads per centimetre and is, in fact, twice as fine as the 260T. When selecting and ordering mesh it should be absolutely clear whether inches or centimetres are being referred to, although the number value of a mesh in the inch scale is not repeated in the centimetre range.

MESH MEASUREMENT

When selecting mesh the terms 'mesh opening' and 'open printing area' may occur. The *mesh opening*, which is measured in microns, is a term that refers to the distance between threads, and is used for assessing the passage of ink through the mesh as the pigmentation of ink is also measured in microns. The pigmentation of ink varies enormously throughout the diverse range that is available. The mesh opening must be at least $2\frac{1}{2}$ to 3 times the micron size of the ink pigmentation in order to allow freedom from blockage and ease of printing. Also, the mesh opening in a mesh of the same thread count will vary according to the thread thickness grade: for example, a 100 HD mesh will have a considerably smaller mesh opening than a 100 S.

The *open printing area* of the mesh is a term used to describe the mesh openings as a percentage of the total fabric. Obviously a light-quality mesh will have a greater percentage of open printing area than a heavy-duty mesh of the same thread count.

Different screen mesh manufacturers market products that, despite having the same number and letter descriptions, vary slightly in thread thickness and therefore percentage open printing area, but as the variations are minimal they make very little difference.

There are also mesh qualities (S, M, T or HD) that exist at a thread count in one manufacturer's range but not in

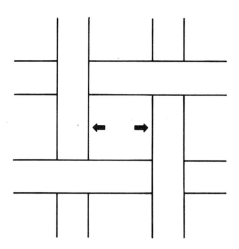

Mesh opening indicated by arrows. The aggregate area of the mesh openings when expressed as a percentage of the total mesh area is known as the open printing area.

Silk Number	% stretching extension for silk	% of open printing area for silk	Thread count for synthetic mesh (nylon polyester)	
			per in.	*per cm*
6xx	2–3	53·00	76T	30T
8xx	2–	46·00	92T	36T
10xx	2–3	36·00	110T	43T
12xx	2–3	29·00	123T	48T
14xx	2–3	30·00	137T	54T
16xx	2–3	25·00	156T	61T
20xx	2–3	27·00	175T	68T
25xx	2–3	25·00	186T	73T
			230T	90T
			260T	100T
			305T	120T
			355T	140T
			420T	165T

another's. A rough comparative table is given here to help in the understanding of mesh grading systems and the relative differences between meshes.

The chart deals with the *xx* and T grades of silk and synthetic mesh respectively. The percentage open printing area will increase or decrease depending on whether a lighter- or a heavier-duty mesh is selected.

Thread mesh counts do go slightly higher than 200 threads per centimetre but this is far beyond the usable range of most screen printers. A good general-purpose mesh for quality hand-cut stencil work would be in the region of 45 threads per cm; for simple photo stencils in the region of 90 threads per cm; and for fine-detail, high-quality photo-stencil work requiring accurate registration the mesh would be at 120 threads per cm and above. T (heavy) is the commonest quality of mesh used in art colleges and studios, but the choice depends on the type of work.

Similar working principles apply to synthetic mesh as to silk. An HD mesh of the same thread count as an s mesh will have thicker threads, less open printing area, and a smaller mesh opening, resulting in a thicker application of ink and less definition in the finest stencil areas. The HD mesh is, of course, much more durable.

Nylon may be moistened evenly before stretching although not all processors do this. Its stretching elongation ranges from 3 to 6 per cent. It must be roughened with a mild abrasive and thoroughly degreased to receive indirect stencils successfully (see Chapter 9, p. 96).

Polyester mesh is the most advanced synthetic mesh available at present. It has all the qualities of nylon plus

Cross-section of meshes of the same thread count but with different thread thicknesses showing the differences in the resulting ink deposits.

% stretching extension for nylon	open printing area for nylon	% stretching extension for polyester	% open printing area for polyester
3·50	40·50	1	38·50
3·50	43·25	1	42·00
3·50	41·25	1	43·50
3·50	44·50	1	43·50
3·50	45·25	1·5	41·75
4·00	39·75	1·5	34·50
4·00	34·50	1·5	38·75
4·50	42·50	1·5	35·75
4·50	38·25	2·0	32·50
5·50	35·75	2·0	37·00
5·50	34·50	2·0	36·75
6	25·50	2·5	29·25
6	21·50	2·5	20·50

Comparative listing of mesh types

the extremely important advantage of greater stability, due to a considerably reduced elasticity and a high resistance to moisture. Nylon, although nowhere nearly as absorbent as silk, is ten times as absorbent as polyester, and this, together with its greater elongation, can cause untoward movement during printing which will result in bad registration. This problem increases in proportion to the size of the screen. The high registration accuracy of polyester mesh makes it the most frequently recommended mesh for printing; it is used in industry for such specialist work as printed circuits and calibrated scales, where dimensional accuracy is vital. Nylon, however, has one main advantage over polyester: polyester's low elasticity makes it unsuitable for printing uneven surfaces such as stippled plastic, textured and embossed papers and curved surfaces, so nylon, with its high elasticity, is chosen for this sort of work.

Polyester should not be wetted before stretching. It has a stretching elongation of 1 to 2·5 per cent, depending on the thread count. It should be degreased and roughened with a mild abrasive before stencil mounting.

Red and orange mesh

Both nylon and polyester fabrics are marketed in a version dyed red or orange. The mesh is exactly the same as its white equivalent except in this one respect. It has been specially developed in order to cut down on unwanted diffusion and reflection of light during direct photostencil exposure, thus ensuring highly accurate stencil reproductions (see Chapter 9, pp. 101–2).

Static electricity

Synthetic meshes have an occasional tendency to create static electricity. This is caused by a combination effect from the squeegee action on the screen, the printing stock and the atmosphere in the print room. It can result in problems with the printed paper sticking to the stencil, or small irritating static electrical shocks to the printer. This can be avoided either by using anti-static aerosols or liquids or, in the case of shocks, by earthing the rack and press.

METAL SCREEN-PRINTING MESHES

Polyester mesh has largely taken over as a printing mesh in fields previously reserved for stainless steel and bronze wire meshes, which in fact were developed to improve on nylon for specialized jobs such as printed circuit and calibrated scale production. These are still used in conjunction with highly abrasive and crystalline inks and also with thermoplastic inks that require electrical screen thread heating during printing. The one great disadvantage with metallic screens is that they are easily dented. One further development from polyester and metal meshes is the manufacture of metal-clad polyester, which combines every conceivable advantage of screen mesh but is inevitably expensive.

Of all the meshes discussed, polyester monofilament would appear to combine all the advantages that currently relate to the printmaker. It is however, for the artist to decide which material to use for his particular purposes, but to do this it is important to have an understanding of the data concerning ink, stencils and printing stock. Many of the frustrations associated with screen printing are merely the result of minor incompatibilities between materials, which could easily be eradicated with a knowledge of the principles governing the use of these materials.

5 Stretching the mesh

There are various methods of mesh stretching, ranging in sophistication from hand stretching to pneumatically controlled stretching clamps. It is important in screen printing to be fully aware of the level of operation that is being undertaken and to tailor the procedure and equipment accordingly, in this case by choosing the most appropriate stretching method for the job.

HAND STRETCHING

Stretching the screen mesh by hand is the simplest and, in terms of equipment expenditure, the least expensive method. It is also, however, the most unreliable. Only wooden frames can be stretched by hand.

In general it is regarded as economically pointless to hand-stretch synthetic meshes as they are manufactured to a high quality that would be completely unexploited in the hand-stretched screen.

That is not to say that synthetic meshes cannot be stretched by hand, for they can and with results comparable to the organic meshes, silk and organdie.

The method used for stretching mesh by hand bears some similarity to the way in which a painter stretches his canvas. The fabric is placed on the frame and progressively pulled and stapled until it is totally fixed to the frame. A strong staple gun and stretching grippers are a great asset for this procedure.

The piece of mesh should be about 20 cm (8 in.) larger in both dimensions than the outer measurements of the frame and must be laid across the frame so that the two crossing directions of the weave (the warp and the weft) approach the frame sides at right angles.

The first staple is pumped into the mesh at a point halfway along one frame side and as near to the edge as possible. The mesh is then pulled taut and stapled at the exact opposite point on the facing frame side. The same procedure is applied to the centre points of the two other sides, thus creating two intersecting lines of tension along the warp and weft of the mesh. This process is then repeated progressively around the entire frame until the screen mesh has been fully and evenly stretched in both directions. Strips of card can be inserted between the staple and the mesh to prevent the possibility of tearing.

Intersecting lines of tension during hand stretching of the mesh.

Fully hand-stretched screen with stapled edges.

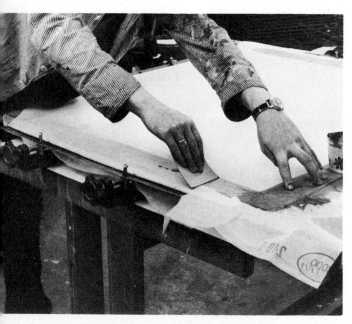

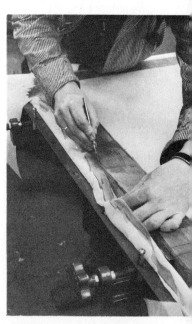

Sticking the mesh to the screen with two–component adhesive.

Cutting away the excess mesh.

The staples should be staggered in order to reduce the possibilities of a split in the mesh. Any staples that rise above the surface should be gently tapped down flush to the wood. The excess mesh, with the exception of about 3 cm (1 in.) all the way around, must be trimmed off and the mesh that is in contact with the wood is then glued. The 3 cm excess is folded over and glued to the side. A water- and solvent-resistant adhesive should be chosen although in reality the glue here is acting only as a support to the staples. Resin W wood glue should prove adequate.

The screen is then taped and lacquered for extra protection.

MECHANICAL MESH STRETCHING

Any one of the mechanical stretching appliances on the market will be far superior to mesh stretching by hand. The equipment available ranges from the simple roller bar method to the use of pneumatic clamps, and most methods are suitable for both wood and metal.

The roller bar stretching method

There are two roller bar stretching methods. The first is the self-stretching screen frame which has already been mentioned and which is similar in manufacture to the four-piece roller bar stretching appliance.

The roller bar stretching device is a versatile and reliable piece of equipment, consisting of four autonomous parts, usually made from aluminium, and each ratchet fitted with a roller bar. The maximum size of screen that this method will accommodate depends on the length of the roller bars but there should be no problems with screens designed to work with anything up to an A0 image.

Regardless of whether the frame is new or old, metal or wood, the mesh bearing surface must be clean and grease-free in order to gain maximum adhesion from the subsequent glueing. Sanding and grinding tools will properly condition both wooden and metal frames for mesh adhesion. Just prior to stretching it is advisable to remove any possible grease deposits from a metal frame with a solvent such as acetone, alcohol or methylated spirit.

The screen frame is placed in the centre of a large flat table. The four roller bar lengths are joined and butted up to the frame edges, with the mesh-receiving surface of the frame slightly higher than the edges of the stretching device. A rectangular or square (depending on frame shape) piece of mesh which is approximately 12 cm (4½ in.) wider all around than the frame is draped over the frame and lined up so that the warp and the weft corres-

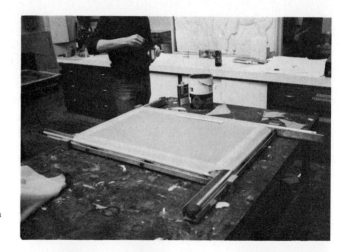

Roller bar stretching device with mesh corners removed to relieve excess tension.

Polak stretching device.

pond to the frame edges: it must be stressed that the warp and the weft should run parallel to the frame sides. The corners of the mesh are the most vulnerable areas during mechanical stretching as they are under the most extreme pressure and can tear not only during stretching but even subsequently owing to inbuilt corner stresses. In this type of stretching method it can be an advantage to trim the corners of the fabric diagonally in order to reduce mesh strain during stretching.

One side of the mesh is then firmly fixed to the roller bar with a length of sticky or double-sided tape. The bar is wound round at least one full turn until the mesh catches itself; this operation is repeated on the opposite side and then on the two adjacent sides. The mesh is then ready for stretching by the proportionate winding of each roller bar in regular succession – the ratchet ensures that the tension can only be increased. There are screw-threaded rectifiers along the stretching length which must be adjusted to prevent the roller bar from bowing inwards under the strain.

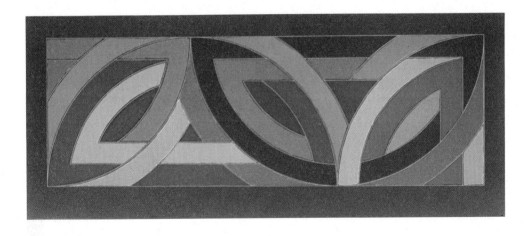

Frank Stella, *York Factory II*, 1974, 47 × 113 cm. Published by Gemini G.E.L., Los Angeles, in an edition of 100. Screen printed onto black Arches paper using hand-drawn positives. 53 printings.

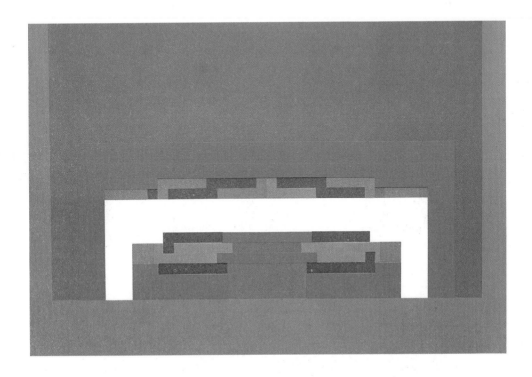

Robyn Denny, *Dream,* 1972, image size 102 × 152 cm. Published by Bernard Jacobson, London, in an edition of 100. Screen printed from an original line drawing plus colour swatches using hand-cut stencils. 8 printings, printed by Advanced Graphics.

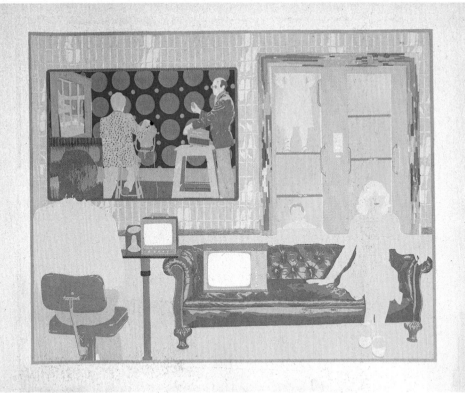

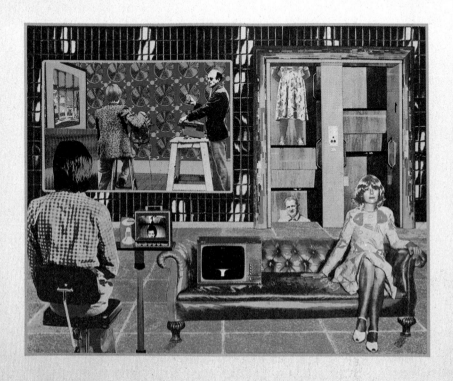

When the mesh is fully stretched (methods of ascertaining the correct stretch are discussed at the end of the chapter) it is ready for glueing. We will assume that a two-component adhesive is used in conjunction with the stretching apparatus. Its properties and composition, together with information on the use of contact adhesives, is given more fully later in this chapter.

The prepared adhesive is applied evenly to the mesh with a cardboard scraper or small squeegee along all four frame sides. The tension is sufficient to ensure the maximum contact between the frame and mesh during setting. When the adhesive has set, all the excess mesh is cut away from the frame. A small extra trim may be retained for glueing along the frame sides.

Polak stretching frame

The Polak stretching system is another simple mechanical stretching method. Eight screw grips, two per side, are fitted to the frame. Four stretching lengths, one each side, are then attached to these screw grips. The four sides of the piece of fabric are clamped into each length by a groove and bar method. Each stretching length is progressively pulled away from the frame by the action of the eight screw grips and so the fabric is stretched to the correct tension ready for glueing.

There are other stretching machines which work on a similar principle but which consist of one integral unit operated by crank wheels and pulleys.

The pin rail stretching appliance

The pin rail stretching method is the same in principle but different in mesh attachment from the stretching appliances already mentioned. The equipment may consist of four long pin rails, one along each frame side and

Opposite: Tim Mara, *Power Cuts Imminent*, 1975, image size 78 × 98 cm on Invercote D. paper. Published by the artist in an edition of 30. Screen printed from a photomontage (photographed studio set-ups and parts of city architecture) using hand-cut, hand-painted and photographic stencils. The upper picture shows the print at its half-way stage with all the hand-cut and hand-painted stencils laid down. The lower picture shows the finished work with all the remaining colours overprinted from one direct photo stencil, which was used in conjunction with cellulose filler in order to isolate each colour area. 72 printings, printed by the artist.

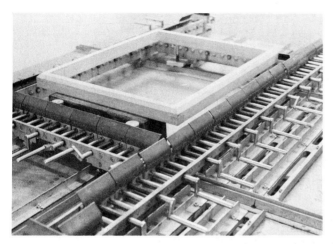

Pin rail stretching device (photograph by Andrew Folan).

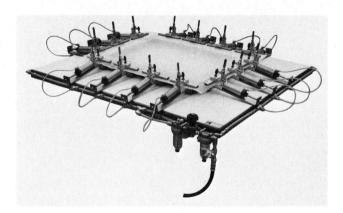

KPX pneumatic screen-stretching
appliance with individual clamps
(photograph courtesy of Pronk, Davis
& Rusby Ltd).

each having one crank handle, or numerous smaller and
independently cranked pin plates arranged in a straight
line parallel to the four frame sides.

The frame is placed in the centre of the appliance with
its mesh-receiving surface slightly higher than the sup-
porting edges. The piece of fabric is draped in position
across the frame and its sides are pressed onto the pin
plates with a hand brush. The pin plate crank handles are
then turned in a regular progression that imitates the
tensioning method of the hand-stretched screen.

The mesh corners are left loose and are progressively
pressed into the corner pin plates during stretching, to
avoid over-stretching with resultant tearing. The
stretched mesh is then glued. The pin rail method is not
recommended for use with fine mesh counts.

Pneumatic stretching machines

Pneumatic stretching machines, because of their expense
and the need for expert maintenance, are generally used
only by industrial printing enterprises and screen process
suppliers. They currently represent the best and most
accurate methods of screen stretching. They fall into two
categories: firstly there is the device which pneumatically
presses the whole screen frame up to meet a convention-
ally stretched mesh, and secondly, and more commonly,
there is the type which incorporates individual pneumatic
clamps. These clamps are fitted round the work surface in
such a way that they pull the mesh over the frame
towards the clamps; or they can be attached directly to
the frame, in which case they push themselves outwards,
stretching the mesh at the same time.

Some pneumatic stretching devices incorporate
clamps on rollers, which can move laterally to follow the
slightest movement of the mesh, thus ensuring the even
tension which is vital for fine detail work. The correct
stretching tension in pneumatic machines is controlled by
and measured from pressure gauges.

It is advisable in all stretching methods to allow the mesh to 'rest' for a minute or two at intervals so that it can adjust to its new tension.

TENSION MEASUREMENT

It is not enough, when using synthetic meshes and mechanical stretching appliances, to measure the tension either by poking the mesh with an outstretched finger or by the traditional dropping of a coin on it. Correct tension is extremely important to the registration of a print and therefore must be achieved accurately.

Each screen fabric has a different percentage of optimum stretch which is related to its tearing point, and the manufacturers of the mesh recommend a percentage stretching extension for all their products. If it is assumed that a mesh requiring a 5 per cent extension is being stretched the tension can be most simply measured as follows.

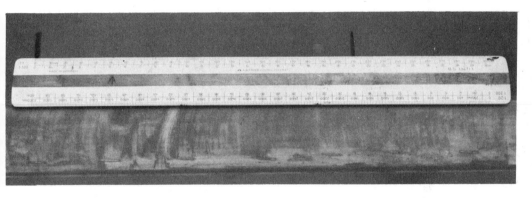

The mesh is first stretched over the frame to a point where it has just lost its wrinkles but has not started to tense. Two points are marked on the mesh warp 20 cm apart and another two on the weft also 20 cm apart. The mesh is stretched and frequently measured until both sets of points are 21 cm apart. The extra centimetre represents the 5 per cent extension.

A stretch percentage gauge is easily made, to facilitate measurement.

Measuring the mesh elongation (in this case 5 per cent over a 20 cm length).

Mesh stretch/elongation gauge. Each small calibration is equal to 1 per cent of the large one.

There are other methods of tension measurement, such as the previously mentioned pressure gauge on the pneumatic clamps which measures in kg per cm as opposed to distance percentage. Manufacturers give

stretching information in terms of both elongation and kg/cm.

Other methods of determining the correct tension include the measurement of the sag in the fabric under the influence of a given weight and in another case the rotation of small wheels by the movement of the stretching mesh will tell the progress of the tension.

In all mechanical mesh stretching it is advisable to pay particular attention to the corners, where the mesh is most vulnerable. As has already been described for the pin rail method, the corners are left loose until towards the end – this can be adapted for roller bar and clamping bar methods. Pneumatic methods are ideal because they can be regulated to control the pressure accurately at the corners. For this reason it is advisable to have screens stretched professionally if a highly detailed print result is required.

ADHESIVES

As we have already seen, there are two main types of adhesives used in conjunction with mechanical frame stretching, contact adhesive and two-component adhesive. Contact adhesive is used in cases where the screen is not in contact with the mesh during stretching. The frame is brought into contact with the mesh on the master frame after it has been fully stretched. The contact adhesive is painted onto both the frame and the stretched fabric, which has been previously marked with the outline of the screen frame. The adhesive is left to dry for a few minutes before contact, when the two surfaces are brought into contact and adhesion is instant. This operation can be done either horizontally or vertically as minimal pressure is required. The stretched mesh on the master frame will receive as many frames as will fit at one glueing. After about five minutes the newly stretched frames can be cut away from the master, leaving a small excess for adhesion to the frame sides (see p. 32).

The advantage of contact adhesive is its speed of setting but this is balanced by its incomplete resistance to solvents.

Two-component adhesives, as their name implies, are marketed in two parts, which have to be mixed to create the setting reaction. The main components are on the one hand the derivatives from synthetic resins, e.g. epoxies and polyurethane, and on the other hand the catalyst hardening agent which sets the bond between mesh and frame.

The two parts are mixed strictly according to the manufacturer's instructions and squeegeed directly through the mesh onto the frame. This adhesive may overlap the frame by about 4 cm ($1\frac{1}{2}$ in.) to ensure a seal at

the mesh/frame join. Depending on the product and on the proportion of hardening agent to base, the setting reaction can take from 10 minutes to 30 minutes, so the adhesive mixture has a very short pot life and must be rapidly applied. When the adhesive is set the mesh is cut away flush to the outer frame edge. It may be necessary to add a few staples to a wooden frame to encourage adhesion in any trough areas that may be present. Weights are sometimes placed in the centre of the stretched mesh to increase its contact with an irregular wooden frame surface, although this will transfer the irregularities to the mesh tension. The best solution is, of course, to make and prepare the frame correctly. On a very small frame it may be necessary to use a weight to ensure full adhesion.

With some two-component adhesives the frame has to be pre-coated with a mixture of the adhesive to aid bonding after the mesh has been stretched. It is well worth having the adhesive solvent (usually acetone) ready to hand during glueing in case of any unwanted glue splashes on the stretched mesh. This solvent will become increasingly inadequate as the adhesive sets.

It is best to leave the screen for 24 hours before using it, to allow the adhesive to set completely.

TAPING AND LACQUERING

Regardless of stretching method, or of whether the screen is made from wood or metal, it is almost always advantageous to tape and lacquer the stretched screen. The function of the lacquer and the tape is to prevent warpage of wood or rusting of metal during washout, to prevent solvent penetration to the glue, to prevent seepage of ink under the mesh/frame join, leading to discoloration of subsequent inks, and to provide a platform for the printing ink.

Four strips of 5-cm (2-in.) brown gumstrip are cut to conform with the four inner measurements of the frame sides. Each one is wetted with a sponge and pressed along the appropriate mesh/frame join at right angles. Four similar strips are cut, sponge-wetted and applied to overlap the existing tape and the mesh. A further four strips are cut, wetted and applied to overlap the tape and the frame sides. Four corner tape sections are devised and stuck into the corners. The screen is then turned over and four more strips of tape are cut to the full dimensions of the screen. These are wetted and stuck down to overlap the mesh and frame joins.

When the tape is fully dry it should be well coated with polyurethane varnish or shellac. There are also some very tough two-component lacquers on the market which will strengthen the tape and increase its sealing power. The lacquering of the whole frame can be left until this point.

As an alternative to taping and lacquering an elastic sealing compound has been developed for pressing into the inner mesh/frame join to prevent solvent penetration and ink seepage.

Aluminium frames are not susceptible to warping and suffer only minimal corrosion. As two-component adhesives are largely solvent-resistant, a well-made aluminium frame, stretched, and fixed with a two-component adhesive can be left free of tape and lacquer except for one strip round all four sides to prevent ink from entering the mesh/frame join.

When the screen is finally ready it is advisable to mark the frame with its mesh description so that its character and function can be easily identified. Mesh remnants should be stored in a filing system and, where manufacturers' mesh identification codes are not present on the selvage, mesh descriptions should be made.

6 Screen-printing equipment

In complete contrast to the sophisticated products marketed by the screen process industry the equipment and materials in use by the artist can be almost as rudimentary as those used in lino or woodcuts. A small extra expenditure can even bring the intricacies of photo stencil printing within the scope of the kitchen-table-top printer.

This chapter will deal mainly with the large items of basic equipment; the necessary sundry equipment will be described in the appropriate chapters.

All the equipment required for producing screen prints can be hand-made by the artist at comparatively little expense and can be scaled to match any environment and to suit the hobbyist as readily as the professional artist. There is, however, a level of reproductive quality which hand-made equipment is unable to achieve, and for this precision-made factory apparatus is essential, but an individual operator who is fully in control of well-made, home-produced equipment can achieve remarkably good results.

MAKING A HAND PRESS

The hand press serves the function of allowing only controlled, regular upward and downward movement of the screen in order to maintain equal registration throughout a series of prints. This movement is regulated by a hinge which secures the screen to a baseboard.

The baseboard is best made from a sheet of 2-cm ($\frac{3}{4}$-in.) plywood laminated with Formica, which will provide a smooth and easily cleaned printing base. Four rubber feet should be screwed to the underside corners of the baseboard to ensure stability during printing.

There are numerous methods of securing the screen to the baseboard all of which work to a greater or lesser degree, but regardless of which method is used, the important point is that the absolute minimum of unwanted movement must be allowed. For this reason it is preferable that the hinge should be the permanent fixture to the baseboard and the screen the removable part. Constant screwing, dismantling and refitting of hinges will both enlarge screwholes and distort hinges to such an extent as to make accurate register impossible.

43

A length of wood of the same depth as the screen frame is glued and screwed along the back edge of the baseboard to serve as a fixing base for the screen mounting frame, which is an outer wooden frame designed to accommodate the screen exactly within itself. The best woods to use are seasoned pine, pirana pine, beech and cedar. This outer mounting frame should be well jointed and accurately made from wood of the same cross-section as the screen itself. The best joint to use is the mortise and tenon, which should be strengthened with a good wood glue. The outer dimensions of the frame should be the same as those of the baseboard. Four bolt holes are then drilled into the mounting frame and rebated on the underside to accommodate the bolt heads. The mounting frame is then attached to the fixing base by means of two door hinges, which must be solidly made with no discernible play between their two halves apart from the purely functional one.

Four bolts are then slipped up through the holes in the mounting frame and the screen is lowered into its inner frame position. Four metal plates are placed over the bolt ends and screwed into the screen frame. (These fixing plates and screws should be of a non-rusting metal if possible.) The bolts are capped by wing nuts which will hold the screen rigidly in position. Note that the drilled holes and the metal plate holes must conform to the bolt size in order to minimize any unwanted movement during printing. 'Snap' or 'lift-off' (which is described in Chapter 11, p. 133) can be created by placing washers on the bolts between the fixing plates and the mounting frame surface.

A simple yet very useful addition to the mounting frame is a 'leg', a thin strip of hardwood which is screwed securely but with a degree of free play along the outer edge of the mounting frame. When the frame is raised during printing the leg will automatically fall and so keep the screen raised, leaving the printer's hands free to remove and replace the printing paper.

There are many ways of making a hand screen-printing press all of which are fully acceptable and prac-

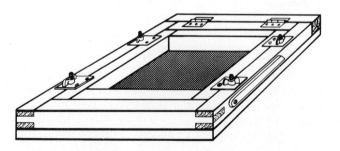

Hand-made screen-printing frame fixed to a mounting frame and baseboard. The 'leg' is on the right hand side.

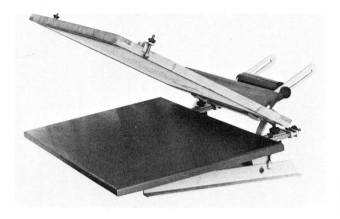

ticable provided that they are fully functional and conform to all the requirements of good register. The advantage of the press described above is that as many screens as are desirable can be made for fitting into the mounting frame and all these frames can be constantly interchanged without interfering with the hingeing mechanism. This greatly reduces the chances of misregistration through the wear on parts.

There is a tendency when printing with the hand press for the printed ink to hold the paper to the underside of the screen stencil, but this problem can be overcome, to some extent, by using double-sided sticky tape on the baseboard. The stickiness of the tape should be reduced before printing starts but this method is, nevertheless, difficult to control, rather time-consuming and consequently disastrous when rapid printing is required.

This problem has, however, been completely overcome by the introduction of the vacuum press which is designed to keep the paper in absolute contact with the baseboard during printing.

MAKING A VACUUM PRESS

It is possible and relatively simple to make a vacuum press as it is, in principle, no different from the hand press. In essence the baseboard of the hand press is replaced by a vacuum baseboard unit while the mounting frame, hingeing method and screen manufacture can remain exactly the same.

The vacuum baseboard unit can be best described as a large but very thin box which is airtight except for a grid system of small holes drilled through its Formica-laminated top surface and a much larger hole cut through its underside. The underside hole accommodates the vacuum pump hose which sucks air in through the grid

45

Grid of holes on a vacuum baseboard unit.

Arrangement of battening inside the vacuum baseboard unit to allow the free flow of air. The central circular hole is the suction hose inlet.

system of holes in order to hold the printing paper rigidly in registration position. The top and the bottom of the box are separated from one another by an outer batten frame and an inner staggered pattern of wood lengths which is arranged both to strengthen the unit and to allow the air to circulate freely.

It is a relatively simple unit to make. Two equal-sized sheets of plywood are required, one of which must have a laminate surface. The grid system of points, regularly spaced at approximately 2-cm (¾-in.) intervals, is marked out on the laminate surface and these points are drilled through with a 2-mm drill bit. The outer batten frame and the staggered system of wood are then glued to the underside with allowance made for the large inlet hole which is meanwhile cut into the other plywood sheet. The two parts are then glued together and left under weights to dry. A water- and solvent-resistant glue should be used.

The vacuum base unit accommodates the hingeing frame and screens in exactly the same way as the hand press baseboard. The vacuum press will need to be mounted on a table-type frame which should be sturdy enough to accommodate the vacuum suction unit. Varying kinds of counterbalancing weights or spring systems can also be incorporated into the press; these will replace the 'leg' used in the hand press by holding the screen up when necessary by their weight.

An ordinary vacuum cleaner makes an excellent suction unit for this type of vacuum baseboard but the cross-sectional size of the vacuum-cleaner hose must correspond exactly to the baseboard inlet hole, to ensure an airtight fit.

It is also necessary to incorporate into the press a means of switching the vacuum suction on and off during printing, either by actually switching the pump on and off or by redirecting the vacuum suction when paper release is required. The former can be achieved by hand switching or by making a foot-operated floor switch, which is a far superior method as it leaves the printer's hands free to deal with paper racking and so allows a more rapid printing operation.

As previously mentioned, there is a point at which this type of hand-made press – vacuum or otherwise – becomes inadequate, and the job in hand reaches a level of precision and sophistication that demands highly accurate registration, fine-detail stencils and fast, consistent printing. In theory a hand-made press can go a long way towards meeting these requirements but in practice there are numerous unexpected pitfalls which will collectively make the hand press redundant. It is at this point that we begin to move into the realm of the factory-made screen press. There is, however, a step between the hand-made press and the factory-produced press.

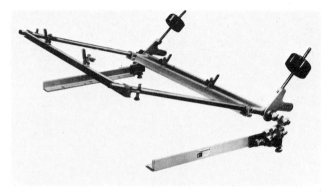

KPX hinge assembly (photograph courtesy of Pronk, Davis & Rusby Ltd).

It is possible to buy individual parts of screen presses from the manufacturers in order to assemble a self-designed vacuum press. The vacuum pump, the vacuum base and the hingeing mechanism can all be bought independently and fitted to a custom-made table structure. If, however, the budget only runs to buying one of these machine parts, then a precision-made hingeing mechanism, which is by far the most important part of any screen press, should have priority.

Illustrated here is a very economically and efficiently made press which has been produced entirely from non-specialist parts with the exception of the counter-balanced hingeing mechanism. The most ingenious part of the design is the method of automatic switching for the vacuum pump which, in this case, is an ordinary domestic vacuum cleaner.

By intersecting the hinge bar with a smaller extension bar it has been possible to harness the upward and downward movement of the screen and exploit it to direct and divert the air suction to and from the vacuum

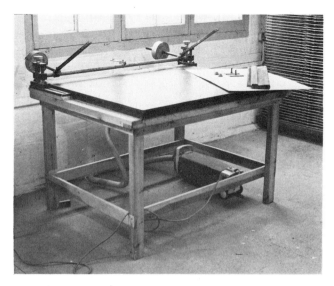

Screen-printing press made by Chris Plowman incorporating a factory-produced hingeing mechanism (note the use of a domestic vacuum cleaner).

Vacuum on–off switching assembly on the Plowman press, which is linked to the upward and downward movement of the screen.

Wooden float used on the Plowman press for diverting the vacuum suction during the operation.

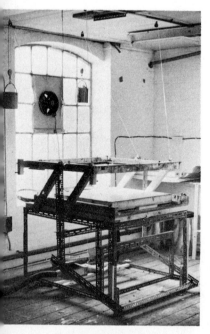

Press with horizontal screen lift made by Bob Linney and Ken Meharg. Note the counterbalancing weights suspended from the ceiling.

baseboard. The extension bar secures one end of a bicycle brake cable length which is attached at the other end (via a pulley at the rear of the press) to a wooden float with a hole cut into it, corresponding in size to the vacuum hose inlet hole. When the screen is raised the float is held forward by a spring mounted at the front underside of the press; in this position the float blocks the inlet hole and the suction is diverted. When the screen is lowered the float is retracted by the brake cable and the holes align to allow the air suction to enter the vacuum unit and thereby hold the printing paper rigidly in its registered position.

Another type of press that can be relatively easily made by the individual is also illustrated here. It is very different from the rear-hinged press in that the screen mounting frame is hinged at the sides. The great advantage of this is that the screen is raised in the horizontal position, which gives much greater control over the ink reservoir on the screen. A vacuum unit and counterbalancing weights can also be designed into the unit.

All these hand-made units can be coated with lacquer for protection against solvents.

FACTORY-MADE PRESSES

In addition to performing all the functions of a home-made press, the vacuum press that is entirely factory-produced should incorporate all the advantages of precision engineering: a rigid hingeing mechanism providing easy attachment for varying screen sizes, highly accurate register guides, registration adjusters, snap adjusters, automatic on-off vacuum switching, a good counterbalancing system and facilities for one-arm squeegee operation (see Chapter 11, pp. 132–45).

The press should be made mainly from metal and should therefore be sturdy and easy to operate, thus

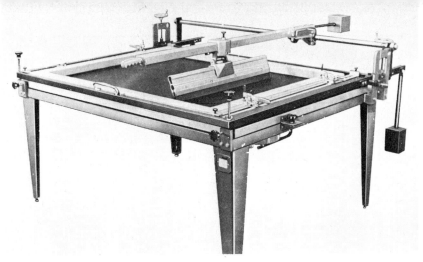

Marler Elite screen-printing press with one-arm squeegee (photograph courtesy of E. T. Marler Ltd).

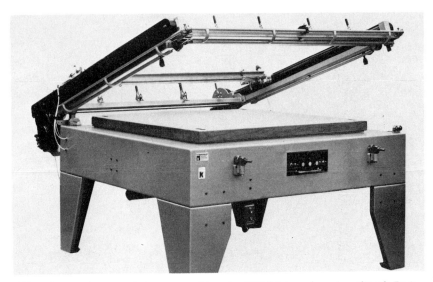

KPX semi-automatic screen-printing press, model number 48.35 (photograph courtesy of Pronk, Davis & Rusby Ltd).

Golia screen-printing press (photograph courtesy of Samco–Strong Ltd).

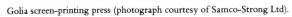

Screen-clamping devices on a Marler Elite printing press.

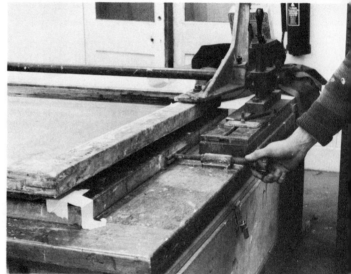

Fine registration adjustment on Golia screen-printing press.

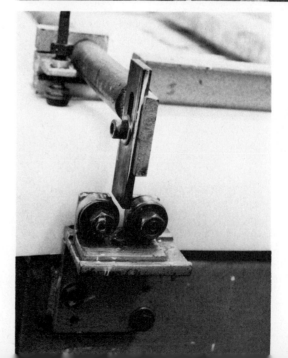

Registration fixing device on KPX screen-printing press.

providing saving of both time and labour. If the
factory-made press does not conform to all these
specifications there is a good chance that it will not pro-
duce results that improve on the hand-made equipment:
there are, in fact, some presses on the market that offer
very little more than can be achieved from two door
hinges, an old vacuum cleaner and a few pieces of wood.

The arrangements on factory-made presses for frame
hingeing, screen attachment, register adjusters, register
guides, snap adjusters, vacuum switching, counter-
balancing and one-arm squeegee operation vary from
press to press but are nevertheless essentially similar.

The hingeing mechanism on a factory-made press
usually consists of a long bar running the full width of the
press and incorporating two precision-made one-piece
hinges. The mounting frame, designed to adjust to any
screen size smaller than its maximum, is attached to these
hinges and, on a good press, can only move in the vertical
plane. The screen is fixed into the mounting frame by
means of four or more incorporated clamps. Some
presses do not have a mounting frame but require the
frame to be bolted directly to the hinge by means of a
cleat which is either welded or screwed to the frame.

Fine registration adjustment is normally made by
tightening or loosening the appropriate bolt adjusters at
the sides of the press; these adjusters will move the entire
base unit.

Registration consistency is normally fixed by a regist-
ration guide device which is a combination of two parts.
One is attached to the press bed and can take the form of
two rollers; in this case the other part will be a piece of
metal which is attached to the mounting frame and which
slots precisely between the two rollers each time the
frame is lowered. An alternative method makes use of the
front snap adjusters which are simply bolts that go
through the frame to the base and are adjustable to pro-
vide the correct snap distance between the screen and the
printing bed. For registration fixing purposes these bolts
are pointed and settle into small pointed concave holes on
the press bed.

Snap or lift-off adjustment, apart from the frontal
method just mentioned, is additionally made by cranking
up the hingeing mechanism at the rear.

Vacuum on-off switching is performed in either one of
two ways: firstly by using the screen action to move the
suction hose backwards and forwards across the base
inlet (similar to the method on the hand-made vacuum
press), or secondly by attaching a cam to one end of the
hingeing bar which will then operate a spring switch
through the action of the screen.

Counterbalancing is invariably performed by attach-
ing weights to extension bars on the other side of the
hingeing mechanism from the screen frame.

EQUIPMENT

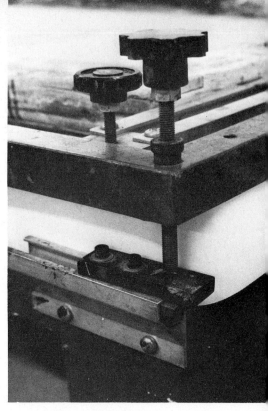

'Snap' adjuster-cum-registration fixer on Marler Elite screen-printing press.

Rear 'snap' adjuster on Marler Elite screen-printing press.

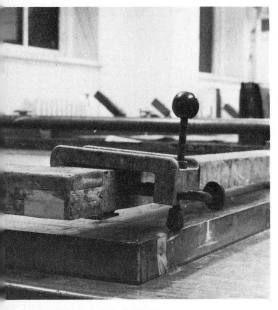

Autonomous 'snap' adjuster.

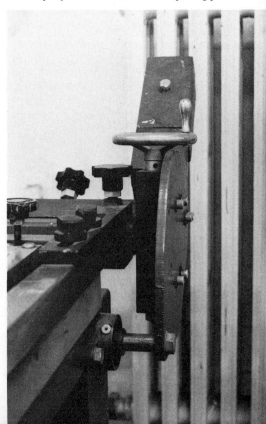

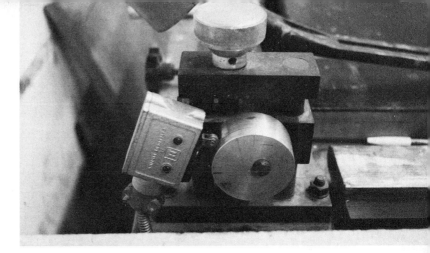

Cam device for switching vacuum on and off.

Switch adaptation to a factory-produced press operated by thigh pressure (photograph by Andrew Folan).

Rear 'snap' adjuster and counterbalancing weights on a Golia screen–printing press.

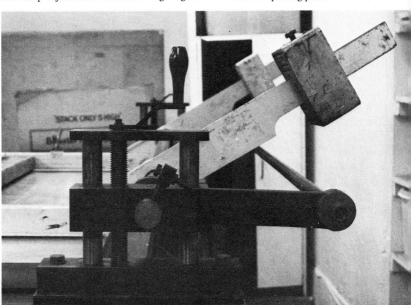

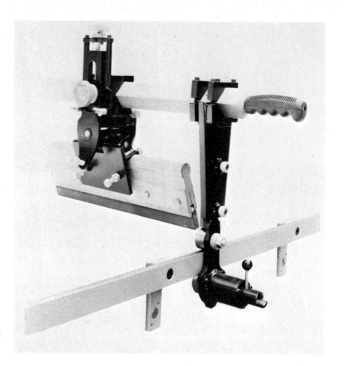

KPX pressure-controlled one-arm
squeegee unit, which ensures consistent
ink application (photograph courtesy of
Pronk, Davis & Rusby Ltd).

The one-arm squeegee action is achieved by mounting an arm-like squeegee carrier at right angles on a second bar which runs above and parallel to the hingeing bar. (Not surprisingly, this one-arm squeegee attachment is so called because it can be operated with one arm.) It allows a smoother, more consistent squeegee pull which in turn maintains accurate registration and an even coating of ink on each print.

The screen process industry has encouraged the development of machinery which is for the mass production of printed paper or other products and which goes far beyond the scope of the hand and semi-automatic presses that are described here. They are based, nevertheless, on the same operational principles and many of their design benefits filter back to individual operation.

THE SQUEEGEE

The function of the squeegee is to pull the reservoir of ink smoothly across the surface of the screen, forcing it through the open stencil areas of the mesh to leave an evenly printed image on the printing stock.

The squeegee is a very simple device made from two parts. The first part is the blade, which in the past was made from rubber but which is now most commonly made from synthetic compositions such as neoprene, Vulkollan or polyurethane. These synthetic blades come in three grades, soft, medium and hard, and are also

produced in different sizes; the commonest one in use for paper printing is 50 × 9 mm (2 × ⅜ in.) in cross-section. They have an extremely long and useful life compared with rubber blades, which are not resistant to all solvents and, as they are liable to perish, require constant resharpening to maintain their printing edge.

The second part of the squeegee is the blade holder or handle, which can be made from metal or. more commonly, wood.

Making a squeegee is really a simple matter of sandwiching the blade between two pieces of wood. As in the manufacture of the screen, it is best to use good wood: three strips are required – one for either side of the blade and another smaller one which fits between the two other pieces and above the squeegee blade, and which must be the same thickness as the blade. Ideally, this third piece should have a 2-cm (¾-in.) groove cut along its whole length, which will allow the sides of the holder to press tight against the blade and keep it secure. The smaller piece of wood is glued between the two larger strips, using water- and solvent-resistant glue. When dry, the sharp edges of the wood are rounded for reasons of both mesh safety and comfort. The blade is slipped firmly into position and several holes at about 7cm (2¾-in.) intervals are drilled through the holder. Tight-fitting screw-and-post couplings are then used to complete the squeegee. It should be taped along both blade-to-wood joins before printing, to prevent discoloration during printing.

Factory-produced squeegees incorporate a machine groove in the handle to allow the squeegee to rest on the screen frame during elevation: this can be imitated in the home-produced one by attaching two lengths of wood along the handle sides.

The factory-produced squeegee will not perform any better than a well-made hand-produced one. It is the blade that does the printing and obviously a home-made squeegee can have a blade every bit as good as the factory product, so in that respect it is not cutting corners in terms of quality to make squeegees oneself.

Cross-section of hand-made squeegee

Two factory-made squeegees. The longer one is for use with a one-arm squeegee device.

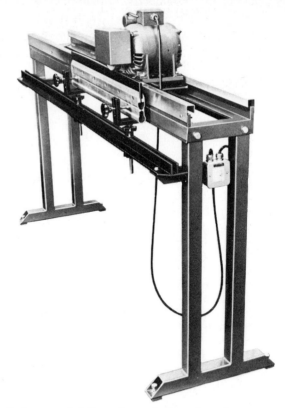

Automatic squeegee sharpener (photograph courtesy of E. T. Marler Ltd).

It is essential for crisp printing that the squeegee is maintained in good condition. As mentioned above, rubber blades will distort and become blunt much more readily than their synthetic counterparts. A blunt blade will deposit a much thicker layer of ink than a sharp one, which may, of course, be desirable, and in that case should be cultivated. An uneven blade will deposit an uneven layer of ink and a blade that is pitted and notched will leave streaks in the printing.

Both rubber and synthetic blades can be reprimed by sharpening. There are squeegee sharpening machines on the market but these are only economical in a large screen-printing plant. A sharpener can be simply made by glueing sandpaper to a length of wood. The squeegee is stroked along this board until a new sharp edge is created. The blade can be reversed in the holder to reveal the unused edges, thus doubling its life. Synthetic blades are liable to harden if stored near excessive heat, but can sometimes be resoftened in hot water.

PRINT DRYING METHODS

By far the best drying method for prints in the normal studio situation is to use a factory-made drying rack, usually comprising a vertical stack of 50 or 75 hinged metal shelves, each of which will accommodate two A1

size prints. The rack is quick and efficient to use. The prints are stacked from the bottom upwards shelf by shelf until the rack is full; it can be emptied very rapidly if the prints are left to overlap the front of each tray slightly.

There are several other methods of drying which range from filling every available surface in the studio with prints to the highly sophisticated industrial production-line stacking methods used in conjunction with specialist inks that dry instantly from ultra-violet light radiation.

At the self-help level, individual trays can be stacked progressively on top of one another during printing, as in the factory-made shelf racking method. A double line of ball racks, although slow to use, is often used by screen printers, and can be imitated very economically by creating a 'washing line' effect. Drilled pegs are arranged at intervals along two lengths of string and kept in place by regularly tied knots. This equipment, however, has the same disadvantages as the ball rack in as much as it is slow and prints tend to be spoiled through contact with one another. The choice of drying method depends on the printing situation and the printing stock. Imaginative improvisations can be made to suit any circumstance.

Print drying rack (photograph courtesy of E. T. Marler Ltd).

STENCIL WASHOUT AND
SCREEN-CLEANING SINKS

Again improvisation, as with all parts of the screen process, can be made to suit any printing circumstance. The kitchen table-top printer can happily use the kitchen sink or even the bath for all his processing, but in a reasonably equipped screen-printing workshop it is essential to have two completely separate sinks – one for dirty work and one for clean.

The clean sink should be kept exclusively for photographic stencil-making and the dirty sink for screen cleaning and degreasing. Both sinks should be trough-like with a large backboard and splashproof surround. The backboard of the stencil washout sink should be made of non-rusting metal and would benefit from an inset of back-lit translucent plastic sheeting, which will clearly show up the quality of the stencils as they are progressively washed out. There must be a hose with a fine spray attachment and also a supply of hot as well as cold

Screen cleaning trough with solvent pump.

Screen cleaning and degreasing unit in use with high pressure water unit.

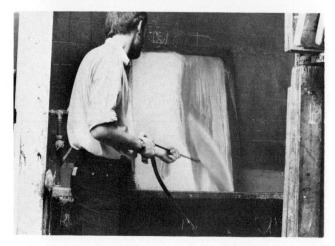

58

water if warm-washout stencils are in use. The exposed stencil can be held in position with magnets.

The screen cleaning and degreasing sink should be much larger than the stencil washout sink and should also have a splash-prevention surround. The water supply need only be cold and should come via a hose spray attachment. A waterproof ventilation fan is also recommended to take away the fumes from the noxious cleaning agents.

High pressure water pumps

The job of screen cleaning is considerably eased if the water is under pressure. Sometimes the water mains pressure in conjunction with a spray attachment is sufficient for the purpose. However, there are several high-pressure units available which can be attached to the water supply hose and which will force water through the screen at pressures of 34 atmospheres (500 lbs/sq in.) which not only speeds up the stencil removal operation enormously but which can even remove otherwise permanent 'ghost images' from the mesh (a result of ink trapped in the screen mesh intersections). It is essential when using a high-pressure unit to install an efficient extractor fan to remove the 'atomized' water which soon fills the air.

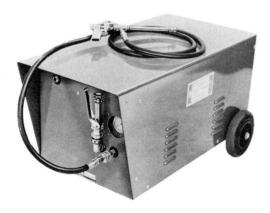

High pressure water unit (photograph courtesy of E. T. Marler Ltd).

7 Manual stencils

Screen printing was originally developed as a method of holding the intricate and isolated parts of hand-cut paper stencils in position, but it has now become the most versatile of all printing forms giving an extremely wide range of stencils to the highest quality on a multitude of surfaces. This has resulted in a process that will not only allow a very tangible and direct approach through the use of hand-made stencils but also a highly technical and precise approach through the use of photo stencils. The scope of available screen-printing stencils ensures a remarkably varied range of printed mark qualities.

This chapter will deal with hand-applied stencils, while photo-mechanical stencils will be dealt with in Chapter 9.

Manual stencils can be subdivided into two groups, direct and indirect: firstly, those that are made directly on the mesh and, secondly, those that are made away from the mesh and are only applied to the screen just before printing.

Both direct and indirect stencils are applied to the ready-stretched screen and are based on the principle that oil will reject water and *vice versa*.

DIRECT STENCILS

Direct stencils range from oil- and water-based liquid fillers (including nail varnish) right through to wax crayons.

Liquid filler stencils

Apart from the traditionally used fillers such as gum arabic and water-based glues, there are several manufactured *water-based fillers* on the market. They are usually red or blue in colour and are for use with oil-based inks.

The basic filler stencil can be made by tracing the design through the screen from the master drawing, photograph or whatever represents the original copy. The non-printing areas of the stencil are then painted onto the screen with the filler. The stencil is ready to print when the filler is dry, which normally takes about 30 minutes unless a warm-air fan is used to speed the process up.

These fillers can be applied to the screen in any way that the artist sees fit – dripped on, sponged on, sprayed

on or even impressed on with filler-coated objects: countless different textures can be achieved by the various methods of filler application to the screen. The finished filler stencils can be washed out with water after use.

In addition to the fillers already mentioned there are rapid-drying fillers on the market which will dry ready for printing in as short a time as one minute. Their speed of drying makes then difficult to use directly for stencil designs but they are extremely useful for quick stencil repairs and for filling in the borders around the screen stencils before printing.

Water-based inks, although not commonly used in conventional screen printing, will obviously need an *oil-based filler* stencil. Oil-based screen ink itself can be used as an oil-based filler and it will suit this purpose admirably, as will wax crayons, lithographic crayons and liquid tusche.

In addition to the fillers already described, there is also a specialist one called 'cellulose filler', which resists both oil- and water-based inks and which will only dissolve in cellulose-based thinners or in screen wash. This is particularly useful for filling in parts of water-based stencils during printing as it can be subsequently removed in order to leave the original stencil intact. Cellulose filler will not break down during printing under the influence of conventional oil-based inks but it can be gently removed with screen wash without affecting the water-based stencil.

Nail varnish (removable with acetone) can also be used as a screen filler but care must be taken when using or devising these more esoteric fillers that their solvents are not harmful – either to the person or to the stencil and mesh.

Wax stencils

Wax crayons and lithographic crayons will form a screen barrier to water-based ink. The stencil is made by directly

Rubbings made from objects with a lithographic crayon for use as a reversal stencil.

Drawing on the screen with oil crayons.

drawing on the screen mesh with the crayon and, although printing the negative of the applied stencil mark, can successfully retain the original drawing quality. Textures can be achieved by placing the screen mesh onto objects or surfaces in order to take wax rubbings: keys, coins and similar flat objects can be represented in this way. The wax crayon will also resist oil-based inks for a few prints before breaking down, which leads to a spin-off process resulting from the dissolution of the crayons in an oil-based solvent.

Oil crayon screen prints

A coarse multifilament screen is required for this process, drawn on with oil pastels exactly as if it were a sheet of paper. The drawing is made on the printing side of the screen using as many colours as is desirable, including all forms of shading, mixing etc.

The coarse screen grates the crayons and traps the particles in the mesh weave: the finished drawing on the screen has all the apparent qualities of a pastel drawing.

The screen is then fixed to the press in the normal way and the printing ink, a mixture of transparent base and screen-wash, is prepared. It is poured onto the screen, then flooded across the mesh and left like this for 15 seconds or so to allow the screen-wash to begin to dissolve the oil pastels. One firm squeegee pull onto a piece of paper will produce a drawing/print, and the printing procedure is then followed as normal (see Chapter 11, p. 136). Ten to fifteen prints can be produced by this method; they will vary in colour depth, with the second or third one being the closest to the original screen drawing. The last two or three prints will be quite pale. The finished prints will retain a slight impression from the mesh weave and will have none of the qualities usually

Taking a print from the oil crayon drawing.

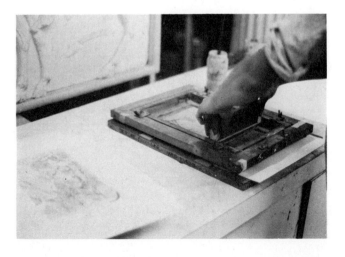

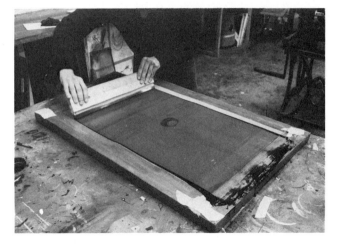

Applying the filler over the tusche.

associated with screen printing but instead will have a soft pastel drawing effect which is faithful to the original on the screen.

Tusche reversal stencils

This is a very common type of stencil that can be made with either liquid tusche or with a lithographic crayon. It is in fact a reversal of the wax stencils that have already been mentioned. The great advantage of it is that the artist can draw exactly what he wants to print because it is a positive stencil process rather than a negative one as in the case of the wax crayon and direct filler stencils.

The drawing is made directly on the screen with either the liquid tusche or crayon, and when finished it is squeegeed over with a thin layer of water-based filler. Gum is very good for this as it seems to be marginally more resistant to the tusche than the proprietary fillers. When the gum is dry the tusche drawing can be removed with white spirit or screen wash, leaving a positive stencil.

INDIRECT STENCILS

Indirect stencils, as already mentioned, are made away from the screen and are subsequently applied to it before printing.

Paper stencils

Paper was the original indirect screen stencil and even now most indirect manual stencils, although improving on paper, still mirror its function.

The thickness of paper used for stencils will determine the thickness of the ink deposit. The paper should be

Working on the screen with tusche.

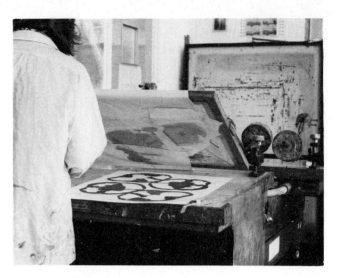

Paper stencil.

smaller than the outside measurement of the screen frame. Newsprint, greaseproof paper and crystal parchment are all suitable.

The paper can be cut with a knife or scissors, torn or perforated, according to the artist's needs. It is, of course, the removed sections of the paper that will eventually print on to the stock. When the stencil is complete it is laid in position on a sheet of the printing paper, which is then laid on the baseboard of the press. The screen is brought down over the stencil and any isolated areas in the stencil are firstly fixed in position on the mesh by dabbing some filler through the screen to make them adhere. This filler is then allowed to dry.

The printing ink is poured along one edge of the screen and the first inked squeegee pull is made. This first pull will, by virtue of the ink deposit, attach the stencil to the underside of the screen. The stencil must then be firmly fixed into position by sellotaping its corners to the underside of the screen frame. The newsprint stencil will last for numerous printings before the ink will begin to penetrate and break it down. Grease-proof and crystal parchment stencils are extremely tough and can be re-used if they are removed from the screen carefully.

Knife-cut film

While paper stencils are adequate at the more fundamental end of screen printing, they are not as reliable or as stable as the manufactured knife-cut films.

There are three basic types of knife-cut film – iron-on, water-based and thinners-based – and all three work on the same principles. Knife-cut film is double-layered. One layer is the stencil coat which is partially removed during cutting in order to create the stencil. The other layer is the backing sheet which is the support for the

stencil and is removable after the stencil has fully adhered to the screen mesh. The cutting is a positive process in that what is cut away is printed.

All films are, to a greater or lesser degree, transparent and can therefore be laid over the master in order to ensure accurate stencil cutting. The great advantages of knife-cut stencil material is that it is durable and will always maintain the isolated stencil areas in their correct relative position to the stencil as a whole, thus making possible the preparation of stencils containing extremely complicated and interrelated shapes.

When using knife-cut film only the top layer of the film must be cut through.

Iron-on stencil film

The iron-on stencil film is shellac-based and is therefore usable with both water- and oil-based inks. The piece of film must be cut larger than the master image that it will represent but smaller than the internal dimensions of the screen frame. It is laid, stencil coat upwards, on top of the master drawing, photograph or print and taped rigidly in position to avoid any movement during cutting. There are several simple stencil-cutting knives on the market but few of these rival the surgeon's scalpel (use straight-edged blades) which is easily available through chemists' shops or surgical supply shops. It is also possible to buy specially manufactured swivel knives which are a great help to the stencil cutter if used properly, as they will travel smoothly round shaped corners and curves.

The knife cut must be just deep enough to penetrate the stencil film but not so deep that it damages the backing sheet. The unwanted portions, which are effectively the printing areas, are peeled away. When the stencil cutting

Various stencil-cutting implements.

is complete the stencil is placed under the screen and is literally ironed onto the mesh through a sheet of paper with a thermostatically controlled domestic iron which has been set to the correct relative temperature for the mesh. When the screen is cool the backing sheet may be removed to allow printing.

The stencil is finally de-coated after use with methylated spirit.

Water-based knife-cut film

Water-based knife-cut film is the most appropriate and most easily used knife-cut stencil for conventional screen printing. The cutting procedure for this film is exactly the same as for the iron-on stencil material – the printing image is cut and peeled away from the stencil layer leaving the backing sheet intact.

It is, however, very different in the way it adheres to the screen. A sheet of board is required which is larger than the stencil but smaller than the inner area of the screen. The cut stencil is placed face upwards on this board and the screen, which must be thoroughly clean and degreased, is laid down on top of the stencil.

The stencil is then stuck to the screen through careful dabbing and wiping with a wet sponge, which deepens the stencil colour and gives a guide to how well the adhesion is progressing. This sponging must be done progressively from one screen side right across the whole stencil area, making sure that the entire stencil is taking to the mesh properly. An overdamp sponge will soften the stencil and destroy any sharp edges. When the stencil has been fully dampened it must be immediately blotted with

Mounting a hand-cut stencil on the screen using a damp sponge.

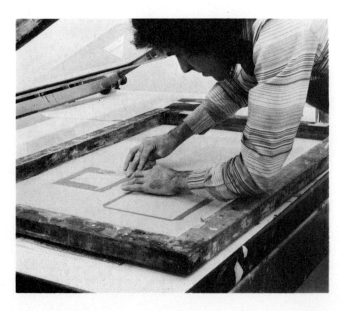

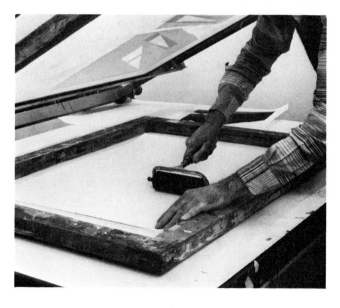

Removing excess moisture from the stencil with a roller and clean newsprint.

clean newsprint in order to remove all excess moisture. Finally a sheet of newsprint can be left under a weighted board resting on the mesh but above the stencil for a few minutes to improve adhesion, but this is not normally necessary.

When the stencil is dry (this can be speeded up with a medium heated fan) the backing sheet can be peeled away. If the sheet is reluctant to move it means that the stencil requires further drying time.

The stencil is eventually de-coated with water wash-out.

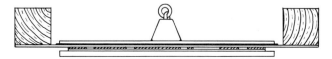

Mounting the indirect stencil onto the screen. The layers beneath the weight are (*from the top downwards*) board, newsprint, mesh, stencil emulsion, backing sheet, mounting board. Indirect photo stencils are mounted in the same way.

Lacquer-type knife-cut film

This knife-cut film works in the same way as the water-based film with the obvious exception of the solvent that is used for its adhesion and removal, which in this case is lacquer-type thinners and which must be applied with as much care as the water damping procedure in the last stencil.

There remains some disagreement among printers with regard to jobs requiring more than one stencil, as to whether each stencil should be cut to the master or to a print taken from each previous stencil. It is normally wisest to cut all stencils to the master as any print taken

from a stencil will never be exactly the same size as that stencil owing to mesh stretch resulting from squeegee pressure. Therefore to cut stencils from printed results will only compound the error.

All the printing for the different stencils must be pulled in the same squeegee direction so that (theoretically at least) all distortion will fall into its correct relative position. Mesh stretch is porportional to the stencil size and the mesh tension, and can be largely eliminated by careful screen making. If a number of screens are in use it is important that they are all stretched to the same tension.

The knife-cut film is usually transparent enough to allow all the stencils to be cut one above the other in relation to the master, thereby increasing their accuracy. Each stencil image should slightly overlap the previous one by approximately 1 or 2 mm in order to ensure a registration overlap and avoid hairline non-printing areas between printed colours.

Wherever possible it is an advantage to print the lightest tones first, followed by the darker ones. Stencils must be carefully located on the screens so that they will, firstly, relate properly to their desired position on the printing stock and, secondly, not be so close to the frame edge that they prevent correct use of the squeegee.

As differing brands of knife-cut film have variable working methods it is extremely important both to read and to follow carefully the manufacturer's instructions.

Found stencil

There are numerous shaped and perforated wrappings and paper products in circulation that can become excellent ready-made stencils – for example paper doilies, perforated fancy packaging, punch cards, computer tape, knitting machine programme cards, plastic netting, typing stencils etc. These can all be used as manual stencils in screen printing.

French chalk stencil

This is a stencil with a limited life, that will normally only allow a maximum of 15 prints before breaking down. The prints resulting from this type of stencil are, however, very uncharacteristic of screen-printing quality.

French chalk or talcum powder is sieved evenly on to a piece of dark paper which is resting on the press bed. It is then drawn into with fingers, knitting needles, feathers or anything that is considered appropriate. The screen is lowered over the french chalk, inked and squeegeed; the powder adheres to the screen and forms a stencil. Printing is then continued until it ceases to function. Fuller's earth can also be used for this purpose, and being grittier it holds better in the screen.

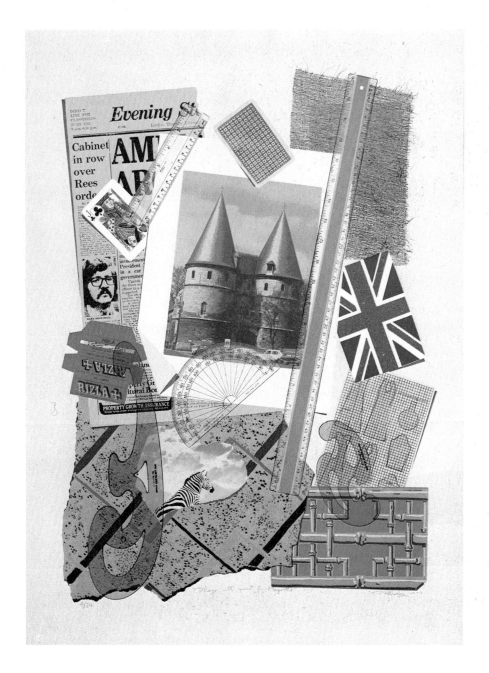

Chris Plowman, *Collage with Insert for Magritte,* 1977, 78·7 × 53·3 cm on Bockingford paper. Published by the artist in an edition of 30. Screen printed using hand-cut, hand-painted, Kodatrace and photographic stencils. This print fuses a wide variety of screen-printing techniques including blending, posterization and the use of 'found' positives (therefore the ruler, muslin and geometry instruments are all printed actual size). Great use is made of transparent inks and varnishes. 34 printings, printed by the artist.

Ken Danby, *Early Autumn*, 1971, 46 × 61 cm. Published by Gallery Moos Ltd, Toronto. Screen printed using photo stencils made from hand-drawn and -painted acetate. No photographic positives were used in this work.

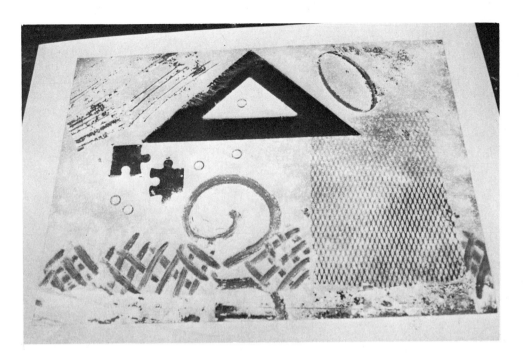

Tape stencils

French chalk drawing for use as a stencil.

Sellotape, masking tape and gumstrip can all be used as parts of stencils or as stencils in their own right, although in the case of Sellotape and masking tape their adhesive will dissolve under the influence of the ink and begin to interfere with the image. These tapes are also useful for repairing stencils and filling leaks during printing.

Sellotape is particularly useful for shielding various details of both direct and indirect stencils which may be required only for later printing. The Sellotape is rollered down in position on the ink side of the screen (in the case of indirect stencils) so that the constant pressure of the squeegee pull will not remove it. After the print run has been made it can be removed, leaving the original stencil intact and the shielded areas available for printing.

Sellotape is also used to create stencils for printing the square or rectangular blocks of colour used in some prints. The square or rectangle is marked out on the screen with the tape and then the outer areas are coated with filler, using the tape as a shield. The tape is pulled away and a sharp-edged open area remains.

It is possible and, in fact, usually desirable to use combinations of any or all these stencil types to produce a finished print.

Tape used as a mask in order to make a rectangular area stencil.

71

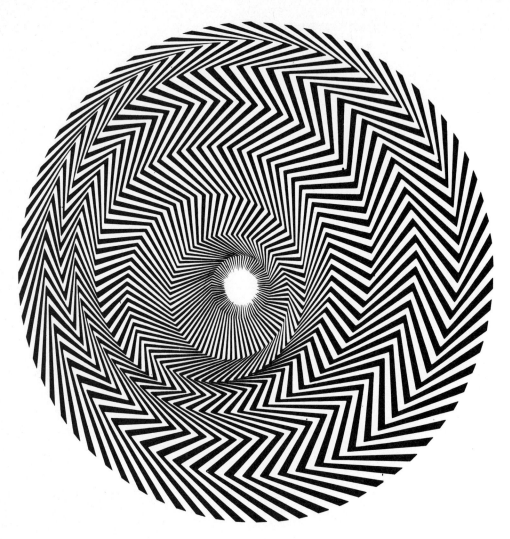

Bridget Riley, *Blaze*, 1964, 53×54 cm. Published by the ICA, London. A one colour screen print (black) on J. Green paper. Printed by Kelpra Studio Ltd, London.

8 Positives for photo screen printing

The photographic positive is so called because it literally is the opposite of a negative: the image is carried on a transparent base and corresponds to both the artwork and the eventual printed image.

For the purpose of this manual a positive is best described as being anything that is brought into contact with the photo-stencil emulsion and is sufficiently opaque to prevent ultra-violet light from penetrating to the corresponding emulsion area during contact exposure. The unexposed area is thus allowed to remain soft during washout in order to render the stencil correctly for the printing image.

FOUND POSITIVES

From this definition it can be taken that although this stencil process is photographic there is in fact no need for the positive to be photographic. The non-photographic positive should, however, be as flat as possible or, if it is a three-dimensional object, it should have at least one flat side and most certainly should not be exposed in a printing-down frame.

Any flat object that is opaque or contains areas of opacity can be used as a positive, and sometimes with better results than if it were photographed to the same scale and then processed as a photographic positive. Each transcription process between the original artwork and the finished print only serves to compromise the quality of the detail. For example, a torn sheet of black paper when used directly as a positive will render the quality of the ragged edges much more successfully than a photographic positive of the same thing.

Apart from torn paper there are limitless possibilities for positives in the huge consumer and packaging industries that now surround us – for example, perforated wrappings, printed polythene or acetate, dyed muslin or net curtaining, window envelopes, gaskets, perforated zinc, fancy cut shapes, jigsaw puzzles, see-through drawing instruments with black engraved markings, or metal combs.

HAND-DRAWN POSITIVES

Screen printing has in the past been considered a relatively crude and unsubtle process. There is a certain

amount of truth in this as fine detail can only be achieved through stringent attention to the quality of mesh and stencil material in use. Tonal hand-drawn marks are normally considered more appropriate for 'ball-grained' lithographic plates but with recent developments in screen mesh quality it is possible to achieve very subtle effects by the direct use of fillers and oil crayons on the mesh (Chapter 7, p. 60). Hand-drawn tonal effects can, however, be more fully controlled by stencil drawings made on acetate and tracing films for subsequent use as positives in photo screen printing.

Matt tracing film such as Kodatrace, Permatrace and even tracing paper with its coarser grain will accurately translate drawings from a variety of implements (such as soft pencils, lithographic crayons, chinagraph pencils and charcoal), through the screen process, into prints. Rubbings can even be taken onto the tracing films from surfaces and objects and used as positives for photo screen printing.

Subtle tonal marks can be screen printed more successfully through the photographic stencil process than the direct mesh method because the stencil emulsion, through its ability to bridge the mesh, will carry the detail more faithfully than directly applied fillers which will inevitably creep into the mesh pattern.

The ability of the screen process to render drawn marks of this type is much underrated and experimentation with recorded results is highly recommended. Specialist dense black drawing ink (TT Rapidograph ink) or red photo opaque, which is a reddish-brown water-soluble chalky compound, can be used for drawing fine lines on tracing films with mapping pens and Rapidographs. Brush strokes and sponged padded textures can be accurately reproduced through these media, as can splattered ink, and ink applied with diffusers and even airbrushes provided that the spray is not too fine.

PRINTED POSITIVES

Positives for photo-stencil work can also be produced by printing existing screen stencils on acetate film with opaque black ink and then using this printed film to act as a positive in the photo-stencil process.

RED MASKING FILM

There are special films on the market which consist of a red emulsion backed by a polyester or vinyl sheet. This red emulsion is entirely opaque to ultra-violet light. The film is cut in exactly the same way as hand-cut stencil film. (The stencil knife cuts only as deep as the backing sheet and the unwanted areas are stripped away.) It is then used as a positive for photo-stencil exposure and is

significantly more accurate than hand-cut film, which has a tendency to soften at the edges during screen adhesion. These red cut films are bonded to the backing sheet in two ways, either electrostatically or with rubber cement. The electrostatic film is not affected by humidity and is therefore stable. The cement film is not so stable but is restickable and so allows mistakes to be corrected. A combination of the two films should be used where high stability with the opportunity for corrections is required.

When using the red film as a positive it must be remembered that it is the remaining parts of the film that will print positively. This is not the case in hand-cut stencil film where the remaining parts of the film block the flow of ink to the paper and therefore act negatively.

Red photographic Sellotape can also be shaped and stuck to tracing film – as indeed can any opaque material – in order to create a positive for screen stencils.

LIQUID PARAFFIN POSITIVES

Before dealing with conventional photographic positives one other short-cut method of producing stencil positives is worth noting. This involves the use of liquid paraffin as a medium for making ostensibly opaque paper become transparent.

Drawings that are made on relatively thin white paper can be immersed in, or coated with, liquid paraffin until the paper appears translucent. All excess paraffin should be squeegeed from the paper. The paper is contacted for exposure in the usual manner (with the drawn side of the paper regarded as its emulsion side) except that for direct stencils a sheet of thin transparent vinyl or polyester film should be placed between the emulsion and the paper so that residual oil does not adhere to the stencil emulsion and impede the washout process. Any oily remains must be wiped from the contact frame glass after exposure.

This liquid paraffin method is rather versatile in that it can be extended for reproduction of invoices, typed matter, illustrations and all manner of thin but opaque printed ephemera. Added to this it is also possible, with some degree of success, to transform bromide photographs directly into positives. The photographs should have high contrast and be printed on very thin paper such as Kodak's P.84 or Kentmere document paper. The results are a bit crude and unpredictable but then how it is used depends on what it is wanted for.

PHOTOGRAPHIC POSITIVES

It is not within the scope of this manual to give a detailed account of the whole photographic process* but rather to deal with the production of photographic positives while presuming that the reader has a knowledge of elementary

* On this aspect, see Richard Chesterman's *Thames and Hudson Manual of Photographic Printmaking*.

75

darkroom procedures. Monochromatic photographic film, for the purposes of this manual, falls into two general categories, panchromatic and orthochromatic.

Panchromatic film is sensitive to the whole colour spectrum and therefore can only be handled in total darkness. It is a continuous-tone film and is used mainly as the negative film in black and white photography. Orthochromatic film is insensitive to light in the red band of the spectrum and consequently can be handled in red safelight conditions. It gives extremely high-contrast results, reducing tone to either black or white. This is known as line photography.

Positives used in stencil making are either line or half-tone positives and will be discussed later in this chapter.

Photographic positives are usually made from orthochromatic film although panchromatic film will give some result when used as a screen process positive. 'Ortho' film consists of photo-sensitive emulsion which has been coated onto a transparent plastic base or onto a translucent paper, and can be bought in sheet or roll form. The emulsion side of the film is the lighter side and is easily discernible under safelight conditions by folding one corner of the film over.

The high contrast of ortho film is such that it divides the tones that it is exposed to into either black or white, i.e. opaque or transparent. Some of the middle tones may be retained in alliance with either the black or the white. This will depend on the quality of the ortho film and on the total range of the exposure material.

The lith developer for ortho films is a high-contrast one and is usually marketed (for better keeping) in two separate parts. The chemicals can be most cheaply bought as powders for conversion into two stock solutions, but they can also be bought in liquid form, either concentrated (to be diluted) or ready for use. The two stock solutions are known as A and B. They are mixed, according to instructions, as needed, on a one-to-one basis, and used at a temperature of 20°C. (68°F.). Once they have been mixed their life is limited by both age and the amount of film that is processed, so fresh stocks must be mixed regularly.

The fixative used in ortho film processing is the same as for 'pan' film. Manufacturers' instructions must be closely followed when using photographic chemicals.

POSITIVES FROM AN ORTHOCHROMATIC NEGATIVE

Artwork

The commonest procedure for producing a positive starts by making a negative from the original artwork or

copy. For the most controlled results it is made with the capabilities of the camera and the film material in mind. Neither the camera nor the film can render detail that is not sympathetically devised in the artwork, and for this reason skilful retouching of photographic artwork with anything from a pencil to an airbrush is essential. It is far easier to correct a detail in the artwork than to attempt to do so in the negative or positive.

Procedure and equipment

The orthochromatic negatives and positives are produced on a process copy camera which can be as basic as a 35 mm camera or as sophisticated as the large-format computerized cameras that are actually designed into the structure of a building with the camera lens wall-mounted in one room and the camera body being the actual darkroom the other side of the wall (perhaps reverting to the original meaning of the word camera, which is the Latin for 'room'). In these sophisticated cameras the film is actually loaded from the process dark-room and a computer calculates and operates the correct focus, exposure and shutter speed. Cameras such as this can only be properly operated by skilled technicians who will process photographic work to the highest quality. If high-quality photo positives are required it is essential to hand the work over to experts.

Other than this there is an enormous range of equipment, of relatively high quality, available for use by any artist with a degree of photo-process knowledge. It is also possible to achieve stunning results through imaginative use of quite ordinary equipment.

Cameras are best chosen or made according to their intended use. For example, it is possible to cut a strip of ortho film from the sheet or roll and tape it to the backing paper from a 120 mm film, roll it up and fit it into a 120 mm camera. It is even possible to obtain 120 mm or 35 mm line film in rolls ready for use, and the camera can then be used normally. The results are relatively crude but certainly usable. The artwork can be flat or three-dimensional and can be photographed under natural or artificial light.

Trial and error will establish the best exposure times. Enlargement is as for normal negative photographic film. Excellent negatives can be made if the studio is fortunate enough to be equipped with a half-plate or whole-plate camera. (Film is available in these sizes or can be cut down from a larger sheet or roll.) This type of camera can be permanently set up in a copy room, in which case it should be rigidly mounted to face a copy frame (similar to a printing-down frame). This copy frame will hold the artwork perfectly flat during exposure. Copy frames can be made with a foam rubber backing to ensure good

Quarter-plate camera trolley-mounted to face the copy frame.

contact between artwork and glass during exposure, and can also be bought with a vacuum back. It is extremely important to mount the camera so that its lens plane is perfectly aligned with the glass surface of the copy frame, to prevent distortion in the artwork from being transferred to the negative during exposure. A permanently set up camera can be fitted to a trolley mount which is located on rails, to aid accurate enlargement and reduction of the copy; it can also be mounted on the wall to face a horizontal copy frame. The copy frame is usually lit equally from both sides, and great care must be taken when setting up the lights that no unwanted reflections from the glass are included in the exposure.

In a permanently set up copy room it is an advantage to make a series of test strip negatives in order to establish an accurate table of exposure values.

The development procedure for ortho film is the same as for ordinary black and white photography except that it is most important to expose the film so that it fully develops at the optimum time (usually $2\frac{1}{2}$–3 minutes). This ensures the best reproduction and also that the remaining emulsion image is dense enough to resist the ultra-violet light during the stencil-making exposure. The developing image will appear on both sides of the film. In general, the non-emulsion side of the film should appear to come up almost fully before the development is stopped. It is, however, more satisfactory to have an accurate table of exposures for consultation. It is also an advantage to have a translucent safelit panel under the developing tray in order to monitor the progress of the negative.

The stop bath can be cold water but is more usually a dilute acetic acid, and is used for stopping development and washing away developer before the film is put into the fixative, which will remove any remaining emulsion

Safe light beneath developing tray to aid the development of positives.

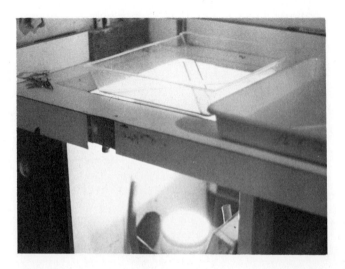

fog from the film. (The rule of thumb is that the film is fully fixed in twice as much time as it takes to clear.) The film is washed for 20 minutes, squeegeed free of excess water and then hung to dry. A dust-free heated drying cabinet is an advantage as the film must be kept free from dust.

The negative is processed to the ortho positive stage by contact exposure, by enlargement or by being used as the artwork for enlarged recopying.

Contact exposure speaks for itself. It is usually an emulsion-to-emulsion contact, whereas enlargement is simply the projection of the negative, in an appropriate enlarger, to whatever positive size is desired.

A back-lit translucent copy frame is required when the positive enlargement is made by rephotographing the negative as artwork. With a large-format copy camera it is possible to make both negatives and fairly large positives without ever needing recourse to an enlarger. Sometimes it is possible to enlarge a positive in two separate halves which can be subsequently spliced together. If this is attempted, good-quality low-shrinkage film must be used or the two halves will not register.

The camera enlarger

In much the same way as it is possible to make a positive without an enlarger it is also possible to make one without a camera. The copy frame is placed at the base of the

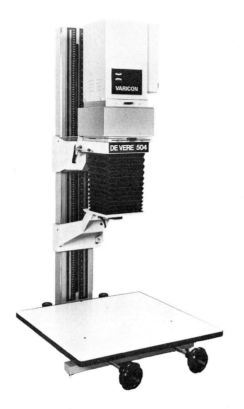

De Vere enlarger which can be used as a copy camera with the addition of side lighting (photograph courtesy of De Vere Ltd).

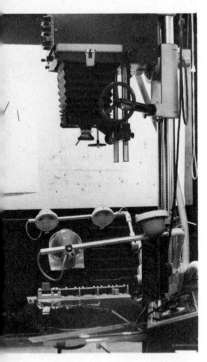

Durst camera/enlarger.

enlarger and lit from both sides. An ordinary negative is placed in the enlarger and focused on the copy frame to ensure that the enlarger and copy frame are correctly focused to one another. The negative is removed, and replaced by unexposed ortho film.

The artwork is placed into the copy frame. The side lights are switched on and the exposure is made. The negative is developed, washed, cut and dried ready for replacement into the enlarger, where it can be blown up to any positive size.

Theoretically, this can be done with any size of enlarger from 35 mm upwards: half-plate and whole-plate enlargers are ideal for conversion to camera enlargers. Given a reasonably good lens, the resulting negatives and positives should be excellent. Attention should always be paid to the correct quality and balance of the side lighting, and a cooling system may also be required. Once the operation is established an accurate table of exposure values should be compiled by recording a series of stepped test negatives and positives. This will ensure the minimum waste of material in the future.

There are many half-plate and whole-plate camera enlargers currently available on the market. The Grant enlarger and Repromaster are excellent all-purpose machines, easy to use, compactly designed with all the elements of a process camera reproduction system rolled into one.

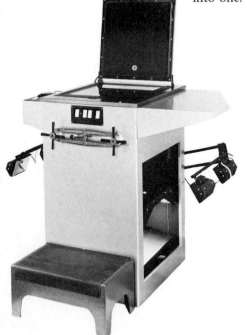

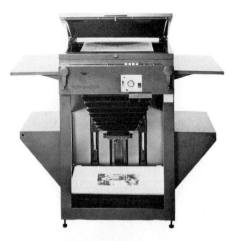

Agfa Repromaster (photograph courtesy of Agfa Gevaert Ltd).

Dual purpose Grant enlarger (photograph courtesy of Grant Equipment and Supplies).

The artwork is loaded into the incorporated copy frame at floor level, and lit from both sides with built-in back lighting to facilitate negative reproduction and enlargement. The lens is bellows-mounted in an adjustable plane above the copy frame, and at the top of this box-like machine there is a sheet of glass for focusing. After focusing, the unexposed film is loaded onto, and brought into complete contact with, the glass by a hinged vacuum pressure back. The exposure is made and is generally regulated by a pre-set clock mechanism. The resulting negatives are enlarged by positive reproduction from the back-lit copy frame.

Autopositive film

Autopositive film was produced by Kodak to eliminate the need in certain cases for the production of the intermediary negative: it is exposed to ultra-violet light in contact with the original artwork to produce, directly, a positive of the same size.

The autopositive film is placed with its emulsion side to the facing side of the artwork. A transparent yellow sheet is placed between the film and the light source and the exposure is made. The film is then developed in the normal A and B lith developer. The manufacturer's recommendations must be very carefully followed when using this film.

TONAL POSITIVES FROM PANCHROMATIC NEGATIVES

It is impossible, in screen printing, to reproduce photographic tones without the intervention of mechanical means. This means that, in fact, all tone in screen printing is an illusion. The simplest way of achieving any tone in a positive that will stand some chance of surviving through to the print is to use an ordinary coarse-grain panchromatic negative for enlargement onto good-quality orthochromatic film. By this method some of the granular quality of the negative will be retained on the periphery of either the black or the white areas of the ortho positive. Skilful stencil making and choice of mesh will determine how much 'tone' will eventually print.

Posterization/tonal separation

Posterization, which originated in screen printing, is the simplest mechanical method of creating the illusion of printed tone. To some extent it relies for its success on the degree of spare tonal qualities that can be retained by the ortho film.

The principle of posterization is that several positives of regular but varied exposure are made from the original

tonal artwork: each will then show a different amount of tonal detail from the original. This range of positives is printed by mixing the same tonal range and number of inks from one colour. The stencil from the densest positive is printed in the lightest ink tone, the other stencils are then rendered in a reversed progression of the ink tonal values until the least dense is printed in the darkest tone. This method of overprinting can very successfully reproduce the illusion of a full photographic tonal range.

The whole process must be carefully controlled so that all the individual negatives are progressively related to one another. The degree of tonal quality depends on strictly methodical processing, and the range of tones will depend on the number of exposure stages. Register guides, e.g. the standard registration cross, should be drawn on the artwork before photographic processing.

In practice, posterization may be tackled in one of two ways. The easiest method is to use a full continuous-tone panchromatic negative in the enlarger. A complete and multi-staged test strip is then made onto ortho film. The exposure stages are selected and the positives made. Anything from three posterizations to twelve or even beyond is effective. Alternatively, a continuous-tone negative can be made from a drawing or photograph and then processed in the same way.

The second method is to place the drawing or continuous-tone photograph into the copy frame and then to make a stepped-test orthochromatic negative. The next step is to select exposure values and make negatives which are then 'contacted' in order to produce positives.

Posterization printing is usually done with opaque inks, although not essentially as there are no hard and fast rules. It is not, of course, even necessary for the inks to be a systematic range of the same colour. Experimental variations in tone and colour are their own reward.

MAKING HALFTONE POSITIVES

The photo screen printing process, in common with most printing processes, cannot 'see' tone. It is only capable of creating flat colour and non-printing areas. For this reason several intervention methods have been devised for recreating continuous tone in a palatable format for screen printing – such as the posterization process already described.

It is helpful to think of printed tone as a compromise of the original tone and to treat it as an entity in its own right.

In simple terms, the effect achieved in a halftone positive is to break up all the tonal areas in the original artwork and translate them to a black dot system. These

Minimum and maximum detail stages
of a posterization (see also p. 69).

dots vary in size and are on an even grid system. In the positive, the large dots are close together and therefore create an illusion of the dark tonal areas. The smaller dots are widely spaced and consequently represent the lighter tonal areas. In this way the complete tonal range of the original artwork can be recreated for halftone printing.

The four-figure symmetry halftone screen is the mechanical device most commonly used for creating illusionary tone from continuous tone in photography. It consists of a grid of criss-crossing opaque line rulings on a transparent glass or plastic backing sheet, which, in magnification, appears as a chequered effect. The half-tone screen is placed between the ortho film and the copy during the standard camera exposure for a negative. The camera is focused in favour of the ortho film with the halftone screen in position at the recommended distance from the film. The tonal areas of the original copy reflect correspondingly greater and lesser amounts of light through to the ortho film. As this light is under the influence of the halftone screen the result on the ortho film is an out-of-focus representation of the halftone screen in relation to the in-focus original copy.

Lastly, in addition to the standard exposure the copy should be replaced by a sheet of white paper and a further 10 per cent of the original exposure should be given to the film, to increase the tonal range of the negative.

The resulting negative is then contacted or projected in order to make the required positive.

The spacing between the halftone screen and the film depends on the type of screen in use, which may, in its turn, be dictated by the make of process camera. It is important to obtain the correct halftone screen for the camera, and *vice versa*.

Modern halftone screens are used in direct contact with ortho film and it is, of course, possible to make halftone positives by placing a continuous-tone panchromatic negative in the enlarger for projection onto ortho film that is in contact with the halftone screen. A halftone positive and an equal-sized line positive of the same image can be exposed together to produce a highly con-trasted, mechanically toned stencil.

A simple stepped test strip can be made to determine the correct exposure value for the production of halftone negatives and positives. The middle tone of the original should be represented in the halftone by an almost equal chequering of black and white squares.

Experience in the field of process photography will obviously create full control over processing and the ability to achieve the exact results required.

Halftone screens are available not only in patterns of opaque lines regularly crossing at 90° to one another but also in numerous other mechanical formations each of which gives a different effect: bead, parallel line and

(opposite) Halftone screen variations. *From the top:* line; wavy line; cross dot; coarse mezzotint. (Screens courtesy of Dainippon Ltd.)

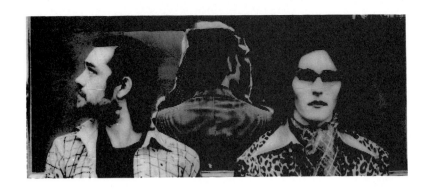

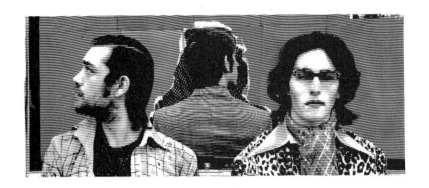

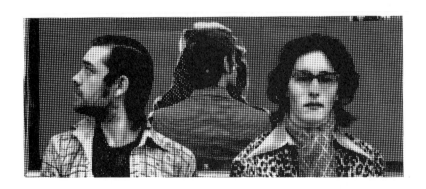

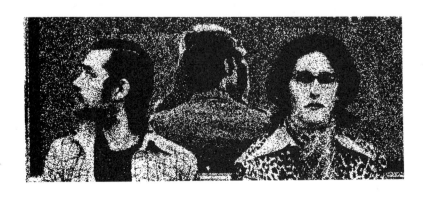

10%

30%

50%

70%

90%

Halftone percentage coverage calibrations.

concentric circle rulings are quite commonly used. There is also a halftone screen known as the mezzotint screen which can create the halftone effect without its mechanical feel. It is screened with a random but regular grain which will imitate the original tone without evidence of a strict grid.

Halftone screens are marketed in a variety of sizes and rulings from 45 to 150 and upwards; the number is the number of lines per inch, and so the higher the number the finer the screen. They are extremely expensive and must be cared for almost to the point of neurosis: they should only be handled at the edges, and every effort must be made to keep them absolutely free from dust and scratches.

The correct screen ruling must be selected for the reproduction procedure that is to be followed. Only a highly specialized screen-printing operation will be capable of continuously printing halftone rulings in excess of 85 lines per inch, which means that a workshop that makes positive through negative contact may only require a halftone screen of 85 lines or less. If, however, positives are made through negative projection then the halftone screen should be a relatively fine one. For instance, any negative that is made through a 120-line halftone screen for four times enlargement will become a 30-line positive.

The selection of halftone printing size for the retention of the illusion of tone largely depends on the distance the finished work is viewed from. Large street posters can be printed at 10 lines per inch; newspaper photographs are commonly about 70 lines per inch.

Autoscreen

Kodak Autoscreen ortho film is an extremely useful addition to the range of process films available. It is a ready-screened negative film which already has within it a halftone ruling of 133 lines per inch which, on exposure and development, manifests itself as a halftone of the original copy. The advantages of this film are numerous: it can be used to produce halftone negatives and positives successfully without recourse to expensive process photographic equipment; it is manufactured in two sizes, 20.3 × 25.4 cm (8 × 10 in.) and 27.9 × 35.5 cm (11 × 14 in.) and can be cut to fit any camera or enlarger; it can be exposed directly under an enlarger containing a continuous-tone negative to produce an instant halftone positive. As with other halftone exposures a flash is required to enhance the tonal quality. An Autoscreen negative will usually require at least a double enlargement to render it usable in normal screen printing (that is from 133 ruling to 66.5). A stepped test strip must always be made to ensure correct exposure and development.

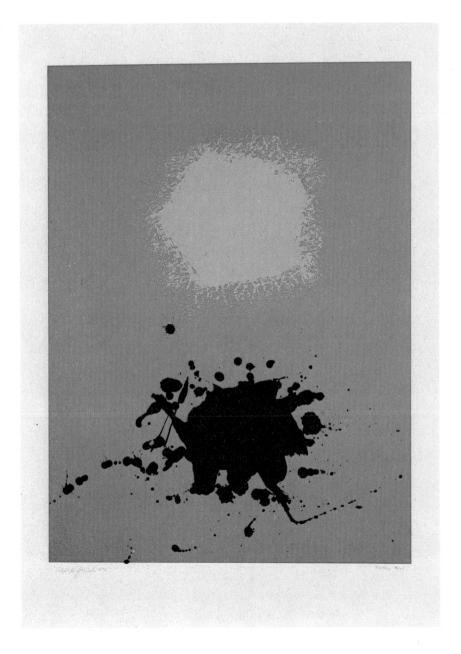

Adolph Gottlieb, *Blue on Green,* 1971, image size 60·6 × 45·3 cm. Published by the Marlborough Gallery, New York, in an edition of 150. Screen printed using both photographic and hand-cut stencils. The black is overprinted with a varnish through the same photo stencil. 4 printings, printed by Kelpra Studio Ltd. Reproduced by kind permission of the Marlborough Gallery, New York.

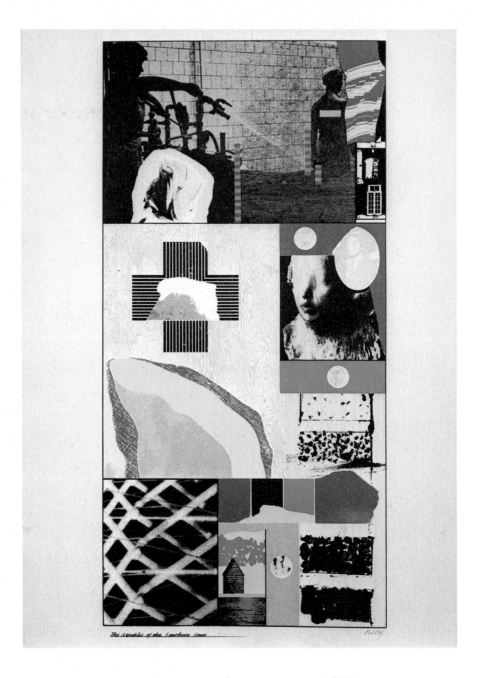

R. B. Kitaj, *Republic of the Southern Cross*, 1965, 77·8 × 56·4 cm on J. Green paper. Published by the Marlborough Gallery, London, in an edition of 70. Screen printed using a combination of hand-cut and photographic stencils. There were seven hand-cut printings and three photostencil printings (all black). Note the use of transparent overprintings. 10 printings, printed by Kelpra Studio Ltd.

Moiré pattern.

Halftone posterization

This term speaks for itself. Posterization stages are made via the halftone screen and subsequently processed as for normal posterization. The results can be very rich in texture.

Retouching positives and negatives

Photographic positives and negatives can be retouched with pens, brushes or airbrushes. Rapidograph ink, indian ink, red photo opaque and numerous other materials can be used. Details can also be scratched or cut away.

PRINTING HALFTONES

The problem with regard to the printable tonal range rests with the ink used in screen printing. This has to be sufficiently fluid to pass through the stencil in the lighter printing areas but not so fluid that it is uncontrollable in the darker ones. It follows that ink that is capable of resolving the very finest halftone detail will cause innumerable bleeding problems at the other end of the tonal range. It is therefore advisable to produce halftone positives that are within the 15–18 per cent coverage range in order to achieve a full printing result, although in practice the printing conditions will generally reduce a full-range halftone to between 15 and 85 per cent.

Selecting the mesh

The selection of mesh is an extremely important factor when printing halftone. There are two points with which particular care must be taken. Firstly, the mesh must be fine enough to support the stencil and yet prevent the halftone dots from falling through the weave, and secondly, it must be selected in order to avoid the possibilities of a moiré pattern developing between the mesh

and the halftone. (As a general rule for printing in the normal halftone range, the mesh count should be approximately four times the count of the halftone screen.) For these reasons care in the production of halftone stencils is critical. Thin stencils will only serve to increase halftone printing problems. Therefore direct or direct/indirect are the most suitable fine halftone stencils.

Moiré patterns

The moiré effect is an optical whirling which can be created by the off-centre overlapping of two transparent crossing grid patterns. It sometimes occurs in screen printing when the halftone stencil is not in true with the mesh weave. The effect can be avoided by paying attention to a number of points.

Indirect stencils are more independent of the mesh weave and will go some way towards overriding the moiré pattern. Direct stencils must be carefully made to ensure correct stencil thickness. The moiré will be less visible if the screen mesh fineness is high in relation to the halftone screen ruling (four times or more). It is also helpful if the *stretched* mesh count is not an exact multiple or half multiple of the halftone screen count (e.g. 3.5 times, 4 times, or 4.5 times). This should be allowed for when selecting the mesh because a mesh can sometimes become an exact multiple by the percentage change in its mesh count through stretching. For example, it is unwise to use a 100-count mesh with a 24-count halftone for, through stretching, the mesh can become a 96-count — exactly four times the halftone count.

There are angles between the halftone and the mesh at which moiré will not occur. The stencil can therefore be angled to the mesh accordingly, but this is a rather unsatisfactory method as it wastes considerable amounts of mesh and is difficult to arrange satisfactorily.

There is no moiré problem with the line, circle and grain ruled halftone screens. Even the elliptical dot bead ruled screen, which is also diagonally criss-crossed, will in some measure avoid moiré.

COLOUR SEPARATION

If it is accepted that three primary colours can represent the whole colour spectrum, then with this basic knowledge of colour theory the principle of colour separation can become a relatively simple one to understand although the production of a successful separation remains a skilful operation requiring a great deal of experience.

Four-colour separation work is printed with a range of specifically made inks (see Chapter 10, p. 121). These inks

are manufactured to stringent requirements setting a standard to which the colour separations must be matched.

Trichromatic inks are capable, through mixing, of reproducing the full colour range, therefore if the original artwork is strictly separated in favour of the trichromatic range the resultant stencils will automatically overprint to reproduce its full colour.

For screen printing the separation is in the form of four halftone positives each one of which is used to make a stencil that will print its individual trichromatic colour. It is possible, and sometimes even desirable, to make a full colour separation requiring only three positives, as black in some cases can kill the vibrancy of an image.

The means for producing the four-colour separation is a set of photographic filters specially manufactured to match the trichromatic inks. The filters, made from gelatin, are placed in front of the camera lens during exposure. In photographic terms the primary colours are red, green and blue. (The difference between the colour theories for light and for pigment, in which the primaries are red, yellow and blue, should not detract from the understanding of the processes described here.) When the red filter is placed between the camera lens and the original colour artwork the red light will pass through, registering as black on the negative, and the green and blue light is absorbed. The red filter negative is therefore minus green and blue. The blue filter, which contains violet, allows blue through and so is minus green and red. The green filter allows green through and is minus red and blue.

When the red negative is projected or contacted to make a positive the positive becomes minus red and is therefore representative of the blue and green. It is consequently printed with cyan trichromatic ink. The positive from the green negative is representative of the blue and red and is printed magenta. Finally the positive from the blue negative is used for printing the yellow. The black stencil is produced through either a special yellow filter or a mixture of filters, depending on the colour bias of the original.

During four-colour processing attention must be paid to the filter factor. This is the exposure compensation that must be made for the varied levels of light absorption by the different filters. The filter factor is always given by the manufacturer of the filter.

The copy can either be a full-colour original which will reflect light during exposure, or a transparency through which light is transmitted.

The colour separation negative is made on panchromatic continuous-tone film, which is sensitive to red, blue and green, rather than on orthochromatic, which is insensitive to red. The panchromatic negative is then contacted

or enlarged through the halftone screen to become the halftone ortho positive.

The production of a colour-separated print is an extremely skilful business and if high-quality results are required there is no other solution than to hand the job over to the professional camera operator who has the necessary knowledge, experience and computerized equipment.

It is, however, as in all aspects of the screen-printing process, possible to produce acceptable results with modest equipment. The information that has already been given in this chapter can be adapted for use with almost any level of process photography.

The easiest way to make a four-colour separation is to use a 35 mm or 120 mm colour transparency in an enlarger; drawings, paintings etc. can be transferred to colour slides for this process.

The transparency is projected through each filter onto continuous-tone pan film stock and individual light readings are taken. The four separated negatives are placed in an enlarger and projected onto ortho film through a halftone screen to make four positives. Conversely, the four negatives could be contacted to make halftone positives directly, and then processed to make the enlargements. This contact processing may be required to save film during halftone screen angling (which is discussed later in this chapter). The procedure obviously depends on the available equipment.

As panchromatic film has to be processed in total darkness, tactile devices must be arranged to enable the transparency projection to register with the film. A useful method of doing this is to fix an enlarger dark slide to the base board, both in position and in focus. The film can then be loaded into the dark slide for each exposure.

Autoscreen can also be very useful in limited situations as a component part of this do-it-yourself four-colour separation.

It would be wise to aim for a fairly coarse halftone dot ruling initially, e.g. 50 dots per inch, as there are quite sufficient processing problems without inviting more. The overlapping halftone colour printing is less obviously mechanical at a 50-dot ruling than a monochrome print would be at the same ruling.

Grey tone scale and other aids

The grey tone scale is a stepped tonal scale showing a range of tones through to black. In halftone production it is placed beside the copy and exposed onto the film at the same time: if the grey scale is consistent with the negative then the negative can be assumed to be reasonably accurate.

Colour tabs of the trichromatic inks can also be included in the copy when making colour separations.

Kodak aids used in process
photography.

The success or otherwise of the negative can be assessed
by the degree of retention or rejection of each colour on
the negative. Full working instructions should be
obtained when purchasing these aids.

Registration marks should be placed or drawn on
opposite sides of the copy during exposure, to aid accu-
racy when printing.

Yellow is a very difficult colour to see when it is
printed, therefore it is helpful to use a blue or brown
overlay film to clarify it during registration setting.

The order of colour printing is traditionally yellow,
followed by magenta, cyan and, lastly, black. This is not a
strict sequence and can be varied to facilitate easier regist-
ration. Registration is extremely important in four-
colour work as slight shifts in printing position will alter
the colour hue of the resulting print.

Avoiding the moiré

This is perhaps the most important aspect of colour sep-
aration, for not only does the moiré created by the mesh
have to be considered as in monochromatic printing but
the potential moirés between the overprinting separa-
tions must also be allowed for. There is an established
system for coping with this problem.

image axis

45° b

30° c

30°

15° m

y

Screen angling used in the production
of 4-colour separation. b = black;
c = cyan; m = magenta; y = yellow.

At the point when the halftone screening is taking place care must be taken to ensure that each separation for each colour is screened at a different and predetermined angle. The normal arrangement for screen angling in a three-colour separation is to angle each one at 30°. With the introduction of the fourth colour, black, the angles alter slightly. The screen for the black is placed at 45° to the image axis, for the cyan at 30° to the black, for the magenta at a further 30° and lastly the yellow (which prints too lightly to show a moiré) is angled at a further 15°.

In sophisticated process cameras the halftone screen will rotate to the required angles. In less grand do-it-yourself procedures screen angling methods must be worked out to fit the circumstances.

Four-colour separation is normally made on a crossed-line symmetrical halftone screen but this should not prevent the artist from experimenting with other screens. (Angling is not required with some alternatively ruled screens.) It is even possible to make posterized separations with two to three tonal stages for each separated colour, but this, in conjunction with halftone screening and the necessary adjustments to the inks, demands a great deal of experience.

Colour correction

Colour correction is a highly specialized process for bringing halftone positives to an exact relationship with the trichromatic inks so that the printed result can be as close as possible to the original.

The professional halftone processor performs this task by skilful retouching or by the use of special masks during the photography. Colour-corrected positives will normally be part of the service provided by a professional processor. If proofing demonstrates the need for correction by the artist processor, then the positives can be remade with more sympathetic exposures. It can also be achieved in some measure by increasing the transparency of the ink or by augmenting it with ink pigment from the jet satin thin film ink range. It must be stressed that these are fairly crude solutions compared with the professional ones, but they are nevertheless effective and can be tailored to the individual artist's needs.

9 Photographic stencils

It has largely been the successful research into screen printing photo stencils that has led the screen process through the rapid and highly complex developments that have taken place in the last two decades. The refinements of the photo stencil, together with its increasing capabilities, have sparked off the expansion of the screen process into completely new areas which have instigated the development of improved machinery, inks and meshes.

These developments in the industry are of direct benefit to the artist as the equipment and materials that he requires are mass-produced and therefore reasonably priced – unlike etching materials and equipment which are hand-made by a few specialists and are very costly.

The inherent versatility of screen printing is equally present in photo stencil as it is in any other aspect of the process. Photo stencils can be made, at one end of the process, by mixing basic chemicals for exposure to the sun and, at the other end, by using manufactured stencil material and precision-made exposure systems. It is as well to know how to operate at the simplest end of photo-stencil work if only to create a better understanding and demystification of the more advanced processing methods which really differ only in their degree of refinement.

In principle the photo stencil is a light-sensitive material that hardens through exposure to ultra-violet light. In use, this material is either coated on the screen or on a temporary support sheet and subsequently stuck to the screen. The stencil material is exposed to ultra-violet light through a positive yet opaque image that has been applied to a transparent film. The ultra-violet light is blocked from influencing the areas of the stencil that are directly in line with the opaque image and consequently those areas are unexposed and relatively soft. During washout the soft stencil areas fall away, leaving the stencil printing image fully described by the hardened residual areas.

DEGREASING AND MESH PRIMING

Before attempting to apply any photographic stencil material to the screen – either directly or indirectly – it is

Particles of domestic scouring powder
trapped in the mesh weave.

essential to prepare the screen properly; it must be thoroughly degreased or it will reject the stencil emulsion and cause printing defects. A 20 per cent caustic soda solution was always considered the best degreasing agent and indeed was the most frequently used. Although the properties of the caustic soda solution render it a highly efficient degreaser its use is no longer justifiable in the light of health and environmental studies, so it is now being superseded by less harmful degreasing agents which are available from screen process suppliers. French chalk is an effective degreaser and some commercial chemical additive versions are also available on the market.

The degreasing powder or solution is generally applied to both sides of the screen with a nylon brush or a sponge and left for 10 minutes to break down chemically the greasy deposits on the screen mesh. It is then thoroughly washed off and the screen is ready to receive the stencil. The stencil should be stuck on directly after degreasing as the mesh is apt to attract grease and dust from the environment.

Domestic scouring powders and cleaning solutions should not be used as degreasing agents for they contain not only large gritty particles which will both damage and lodge in the mesh but also oily chemicals for skin protection such as lanolin, which will adversely affect the stencil adhesion.

If new synthetic mesh is being used in conjunction with an indirect stencil its surface must be roughened to provide some grip for the stencil emulsion. A No. 500 silicon carbide powder is recommended for this purpose, and should be worked onto the stencil side of the screen mesh for a couple of minutes before being completely washed out. Again, domestic scouring powders are not recommended for this purpose.

A further increase in indirect stencil adhesion can be acquired by using manufacturers' bonding agents, which, as they can have an adverse chemical effect on the mesh, should be used only in consultation with the supplier. Usually they are needed only for special jobs.

As with manual stencils, photo stencils are divided into two main groups – direct and indirect.

Direct stencils are coated directly onto the screen mesh and are reputed to be the first type of photo stencil ever used (in the USA, about 1915). The direct stencil was superseded by the indirect (a two-layer film stencil that is processed away from the screen and subsequently stuck in a similar manner to the knife-cut stencil). The indirect stencil cured the problem of ragged edges previously associated with direct stencils. Recent developments in mesh quality have turned the tables and reinstated direct stencils as the more satisfactory – at least for industrial

processing. The most recent developments favour a combination of both – the direct/indirect stencil.

DIRECT STENCILS

Direct stencils are made from colloidal solutions which are light-sensitized by the addition of bichromates or diazos. The resulting solution or emulsion is then coated on to the screen, exposed to ultra-violet light through a diapositive and washed out to reveal the printing stencil.

The colloid is a water-suspended emulsion such as gelatin, glue, albumen or, resulting from recent developments, synthetic resin (PVA/PVAC, or polyvinyl alcohol/polyvinyl acetate). This solution will remain less or more water-soluble according to its exposure to light, the principle being that the areas safeguarded from exposure by the diapositive image will remain at maximum solubility and consequently will dissolve from the screen during washout, leaving a printing area that corresponds exactly to the diapositive image.

At the basic level a bichromatic direct-stencil emulsion can be home-made from numerous formulae, two of which follow. 60 grams* of ammonium bichromate is dissolved into 600 cc of water and then added in the ratio of 1 part solution to 5 parts PVA. A dye (preferably violet) is added to this solution so that the chemical change during exposure can be assessed by the colour change of the emulsion.

Another emulsion formula requires the addition of 40 grams of potassium bichromate, 85 grams of gelatin, 15 grams of glycerine, 30 grams of borax, 40 grams of gum arabic, 340 grams of size, 15 grams of ammonia and some violet dye to 1200 cc of boiling water. This gelatin-based emulsion is not as resistant to water as the PVA and needs special care during washout. These emulsions are then coated on both sides of the thoroughly degreased screen, allowed to dry, brought into contact with the positive and exposed to ultra-violet light.

The sensitized solutions can be stored in a dark place for a short period as the emulsion is not fully sensitive until it is dry on the screen although, as a rule, exposure and washout should follow soon after the screen is dry. The sensitizer (i.e. the bichromate) can be left out of the colloid and added only a few hours before it is actually going to be used.

The coating, drying, exposure and washout of home-produced emulsions are, in principle, exactly the same as will be described later in this chapter for proprietary emulsions. It must be remembered that although home-made solutions are related to industrial emulsions they are extremely crude in comparison, but nevertheless may be preferable where an artist wishes to control the

* For this and similar formulae, the metric system will be used; any attempt to convert is bound to be cumbersome and inaccurate.

effect of the stencil. Home-made emulsions should be carefully tested and any necessary adjustments made to the formula to ensure consistent control over the processing.

It is most important to handle the bichromates with respect as they are skin sensitizers and liable to cause dermatitis, so rubber gloves should be worn. The bichromates must not be stored near heat as it is possible that they might explode – and indeed all chemicals must be handled with respect and with due regard to the possible dangers.

Manufactured screen emulsions are made in much the same way as those already described except that in addition to the bichromate-sensitized colloids there are emulsions that are sensitized with chromium-free diazos.

Emulsions containing chromium (such as bichromate sensitizers) are now becoming obsolete as they make an ecologically harmful effluent and will therefore contravene future environmental regulations.

There is an enormous range of stencil emulsions available on the market which, as well as varying in chromium content, differ in their resistance to both solvents and water. It is important to choose the correct stencil material for each different job by checking with the manufacturers, as well as to follow the makers' instructions very carefully when processing emulsions.

Direct emulsions are generally marketed in a two-part pack – the colloid and the sensitizer. Two-part direct emulsions are usually sensitized by adding the sensitizer to the colloid at the recommended time before coating (it takes at least three hours for the sensitizer to react with the colloid). Premature coating will result in uneven photosensitivity, but fortunately the sensitized emulsion will keep for a reasonable time if it is stored according to the manufacturers' instructions. The coated screens will keep for up to six months (depending on the emulsion) if stored in a cool, dark, dry place. Some emulsions, however, will harden in a relatively short time whether on the screen or not. Careful checking of the properties of the emulsion with the maker is always recommended.

Bichromate-sensitized emulsions are best exposed and washed out soon after the coating has dried. The emulsion only achieves its full sensitivity when dry.

When choosing a direct-stencil emulsion attention must be paid to its degree of water- and solvent-resistance and to its capacity for reproduction of detail work.

These qualities are directly related to the hardening behaviour of the emulsion, which is in turn determined by the constitution of the sensitized colloid. The emulsion will either build up to its optimum hardness as the exposure time increases or it will harden suddenly when the optimum exposure is reached. Gelatin emulsions

normally show a progressive hardening while P V A-type emulsions are most likely to harden at the point of optimum exposure, which renders them less vulnerable to the undermining of detail by the light during exposure. It is extremely important that stencils be exposed to the point of optimum hardness as any subsequent contact of a not fully hardened stencil with moisture will make the stencil swell, and this in turn will cause loss of durability and closing up of the fine detail printing openings. P V A/P V A C emulsions are far less susceptible to moisture swelling than gelatin or gum solutions and, as they also benefit from their hardening qualities, this makes them the ideal stencil emulsion.

Some photo-stencil emulsions will set so hard that they can be used in conjunction with water-based fillers. These fillers can be removed and reapplied without damaging the stencil. Most direct emulsions will at least allow the use of cellulose fillers, which can also be removed without damaging the stencil.

Certain P V A/P V A C emulsions are further hardened by chemical reaction with the appropriate inks during the printing of certain synthetic materials. Additional hardening of P V A/P V A C emulsions can also be achieved by treatment with a solution of 5 per cent formaldehyde (40 per cent) and 1 per cent ammonium bichromate. This is specialist work and manufacturers must be consulted, as this increased hardening will create difficulties in removing the emulsion.

The different emulsions vary considerably in cost and it is worth remembering that the simpler emulsions are markedly cheaper than the more complicated ones, and for the fine artist can be more appropriate to the job in hand. There is no point in buying a top-quality emulsion unless the best mesh, the best screen, a well-made coating trough, and a well-equipped, dust-free studio are available.

Coating the screen with direct emulsion

It is normal to use a coating trough for applying the sensitized emulsion to the screen. The emulsion can, however, be brushed onto the mesh with a camel-hair brush or squeegeed on with a strip of cardboard, or the screen itself can even be surface-dipped into a tray of sensitized emulsion. Some result will be gained whatever method is used for applying the emulsion, and although commercially speaking these other methods are crude it can always be argued that anything can be used where the artist is concerned.

When coating with a trough it is important to refer to the manufacturers' recommendations as the thickness of the stencil is vital to consistent quality in printing. Coating is best performed in yellow or gold safelit conditions.

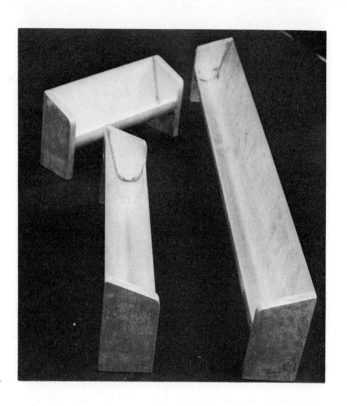

Coating troughs.

The quality of the stencil is directly related to how well the emulsion bridges the mesh and the mesh bridging is governed by the method and number of coatings.

The quality of the coating trough is also extremely important. The best troughs are made from stainless steel or aluminium (2 mm to 4 mm in section); the coating edge should be rounded and the width of the trough must be greater than the width of the diapositive.

Good stencil coating comes with experience but generally three to five sweeps with the trough will be required for a good-quality stencil. Different manufacturers recommend different methods but the object is to make the stencil thicker on the printing side of the mesh in order to provide the best bridging of the mesh in the places where it counts. This is achieved by any one of several methods.

The degreased and dry screen is leaned, ink side inwards, almost vertically against a wall; the loaded trough is brought into contact with the lower mesh and swept upwards in one movement, leaving one coat of emulsion on the screen. The screen is immediately turned round and two further coats are applied to the ink side. The coated screen is then dried horizontally with its printing side downwards, resting it on blocks to keep the emulsion away from dry surfaces. It should be dried in a dust-free, yellow or gold safelit environment where the drying can be speeded up by using a warm fan, or it can be

placed in a drying cabinet specially made for the purpose. When the coated screen is dry (and still in safelight) it is given one or two additional coats on its printing side. It is again dried in the same way, and is then ready for exposure. In an alternative method all five coats can be applied wet-on-wet to the ink side of the screen, and the screen dried as before.

Different manufacturers may recommend varying combinations of wet-on-wet or wet-on-dry coatings but they all have the same objective of good mesh bridging. Poor mesh bridging is manifested by saw-tooth printing edges and concave dips in the stencil surface between the mesh filaments. This provides residual spaces for the ink to seep into during printing and thus can cause endless frustration and loss of control over the printing quality.

In solving the problem of mesh bridging by multiple coating of the screen another problem rears its head. The thicker coatings will require a longer exposure for the emulsion to reach its optimum hardening point. This long exposure will undermine the detail of the stencil image through increased light reflection.

Red and orange screen meshes have been specially developed to overcome this problem as they will readily absorb the reflected light and so help the direct light to produce accurate stencils. The principle behind the dyed mesh is best understood through the description of defects that occur with non-dyed white mesh during direct photo-stencil exposure.

The hardening ultra-violet light passes through the positive (diapositive) and onto the photo emulsion. The emulsion itself will have a certain diffusing effect on the light (which is largely prevented by the dye in the emulsion) but the mesh itself has a considerable reflective and refractive effect on the light, diffusing it quite strongly through the emulsion coat, undercutting the clarity of the

Coating the screen.

Coated screen resting on blocks to dry. This is normally done in safe light conditions.

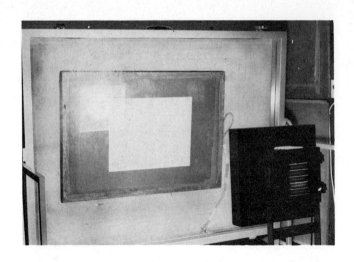

Exposing the coated screen in a printing-down frame.

finest detail and often making the final printing quality unsatisfactory.

Dyed mesh, on the other hand, will absorb the light rays and only reflect non-hardening rays back into the emulsion, thus ensuring stencils of the highest accuracy.

It is extremely important to note that dyed mesh requires between 50 and 70 per cent extra exposure time to achieve correct hardening of the emulsion.

Printing-down frames

As in any contact photographic process it is essential to bring the two emulsions into as close a contact as possible, in this case the emulsion side of the positive and the printing side of the coated screen. There are numerous pieces of equipment on the market for this purpose, known as 'printing-down frames', and they either contain their own ultra-violet light source or are used in conjunction with an independent light source.

In order to clarify the principle of the exposure it is best to deal firstly with the home-made contact and exposure unit.

A very effective contact unit can be made from a sheet of plate glass and a piece of synthetic foam rubber, smaller all round than the inner screen printing frame by approximately 5 cm (2 in.) The foam should be glued onto a piece of plywood of the same size so that their combined depth is greater than the screen printing frame. The screen is placed, printing side up, over the foam block so that the mesh is supported by the foam. The positive is placed emulsion side down on top of the coated mesh and the plate glass is then laid over the positive. The glass may be sufficiently heavy in itself to bring the coated mesh and the positive into the closest contact, but if it is not it can be weighted round its sides to ensure the best possible contact (see p. 109).

This type of exposure is done horizontally with the ultra-violet light source inevitably located overhead. The most convenient light source for this procedure is one or more 125-watt mercury vapour lamps fitted into a light-directing canopy.

Manufactured exposure frames or printing-down frames are normally made from a sheet of heavy plate glass and a sheet of rubber. Both are mounted into a hinged frame which, when locked, is airtight. This is linked to a vacuum pump which enforces contact during exposure. The frames are usually swivel-mounted so that the exposure can be made in either a horizontal or vertical position, depending on whether the light source is suspended overhead or is a floor model. With the frame in the horizontal position the positive is placed, emulsion side upwards, onto the plate glass, which must always be absolutely clean to ensure that no unwanted marks are unwittingly incorporated into the stencil. The screen is lowered, printing side down, onto the positive. The rubber is then brought down over the screen and clamped to the glass, and the vacuum turned on to create ideal contact between positive and emulsion. Sometimes it is necessary to distribute the suction from the vacuum inlet to the far corners of the frame by means of small rigid tubes or even pieces of string. When the contact between the positive and the screen is at its peak the frame is swivelled to face the light source and the exposure is started.

Graphoscreen exposure unit (photograph courtesy of Samco Strong Ltd).

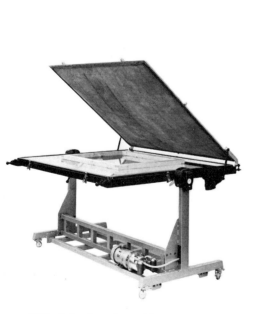

KPX printing-down frame with vacuum pump (photograph courtesy of Pronk, Davis & Rusby Ltd).

Vacuum bag or copy sack

A cheap and effective alternative to the print-down frame is the vacuum bag or copy sack; the sacks on the market are made from heavy-duty plastic and are generally strengthened to increase their life expectancy. This piece of equipment is literally what it says it is; a sack made from one sheet of clear P V C welded along three of its sides to a sheet of black or dark-coloured heavy-duty P V C of the same size. There is an inlet adaptor for the vacuum pump in one corner.

The positive is taped into position on the printing side of the screen and the screen is carefully inserted into the sack. The open end is sealed with the supplied grip bar, the suction is turned on and ideal contact is achieved in readiness for exposure.

Given the right equipment (and in most art institutions a P V C welder is available) it is relatively easy and certainly very cheap to make a vacuum copy sack. The ability of this vacuum sack to produce high-resolution stencils is very good. Its only disadvantage lies in its lack of durability although in a small studio with one or two users the sack can be used hundreds of times.

As the light sources for the exposure of direct and indirect stencils are the same they will not be dealt with here but at the end of this chapter.

Washout of direct stencils

The washout of direct stencils is basically the same for all the different emulsions. The exposed screen, still in safelight conditions, is wetted on both sides and left for about three minutes. It is then washed with a fine spray of cold or lukewarm water (normally from the printing side) until the image is clear and water runs freely down the screen without foam. Screens should not be over-washed as this weakens the stencils, although the better stencils are so tough that the washout will not undermine the stencil image. The washout screen must be gently blotted dry with a clean chamois leather, to avoid the possibility of scumming from the draining water, and finally dried horizontally with a warm-air fan or in a special drying cabinet.

INDIRECT STENCILS

Indirect stencils, as previously stated, are so called because they are made away from the screen and only stuck on after exposure and development. They have the advantage of excellent mesh-bridging. The indirect photo stencil is now commonly manufactured in the form of a two-layer film: one layer is the emulsion and

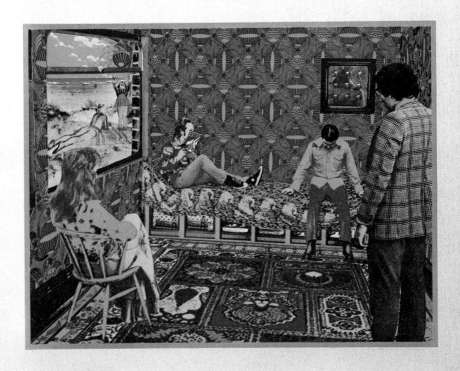

Tim Mara, *Alan's Room*, 1974, image size 78 × 101 cm on Invercote D. paper. Published by the artist in an edition of 25. Screen printed from a photomontage using hand-cut, hand-painted and photographic stencils. The process used was much the same as for *Power Cuts Imminent*, which is described on p. 36. 53 printings, printed by the artist.

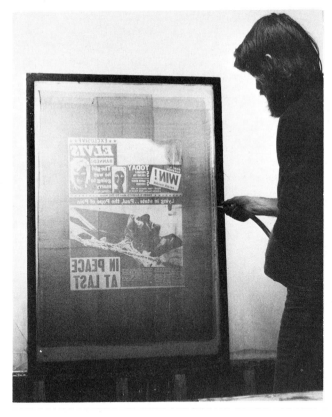

Washing out the exposed screen.

the other the transparent emulsion film carrier or backing sheet, which is made from polyester or vinyl. The most recent and generally the better films are pre-sensitized and require only exposure, development and washout.

The development in the case of indirect films is a hardening process, usually with a hydrogen peroxide solution, which increases the hardening already activated by the ultra-violet exposure.

The carbon tissue method

This was the most frequently used indirect stencil before current developments in the stencil field. It is a rather cumbersome and messy process compared with pre-sensitized film but it will, nevertheless, provide good results and is considerably cheaper.

Carbon tissue is a non-sensitized, paper-backed, gelatin photo-stencil film which is manufactured to be processed by either a wet or a dry method. In both the wet and the dry method the carbon tissue is first made light-sensitive by immersion in a solution of 2 per cent ammonium or potassium bichromate (e.g. 80 grams to 4 litres of water). The emulsion side is then squeegeed against a temporary support of polyester or vinyl film

Opposite above: Gerd Winner, *Hatfield*, 1971, image size 62.5×98 cm. Published by the Marlborough Gallery, in an edition of 75. Screen printed from an original photograph using three hand-cut stencils (yellow, light grey and blue-grey) with four tonal separations overprinted. 7 printings, printed by Kelpra Studio Ltd.

Opposite below: Dieter Rot, *Cologne*, 1970, 70.3×100 cm. Published by the artist in an edition of 110 prints, each unique. Screen printed from a single positive of a picture postcard. Printed on yellow card by H. Kaminski, Düsseldorf, 2–12 printings.

and all traces of excess sensitizing solution are wiped away.

It is at this point that the wet and dry procedures diverge. In the wet method the film (its edges masked before exposure for easier handling during washout) is now ready for exposure. It is exposed and subsequently washed out in a tray of hot water of about 115°F (45°C.) for approximately one minute. The paper backing is then stripped off and the washout is continued until all the excess gelatin is removed and the image is clearly visible. The stencil is chilled in cold water and the film is ready for mounting in much the same way as will be described later for pre-sensitized film.

In the dry method the sensitized and supported film is dried under a cool even fan, in a darkroom because it becomes increasingly light-sensitive as it hardens. (It can be stored in the dry state in a cool dark place for a few days before processing.) When dry it is stripped from the temporary support in readiness for exposure. After exposure it is immersed in cold water for 1½ to 2 minutes, squeegeed back onto the temporary support and further immersed in a tray of hot water. The rest of the procedure is the same as for the wet method.

There is another variation on the carbon-tissue method which involves a non-sensitized film that is supplied ready-coated on a polyester base. It differs from the carbon-tissue method previously described in that it is the paper that is squeegeed to the film during sensitizing rather than the polyester film to the paper, but in principle the process is much the same.

Although the carbon-tissue method is laborious it is economical and an understanding of it does help in the use of pre-sensitized film. The information that has been given so far in this chapter, in fact, enables an inventive operator to make his own indirect film.

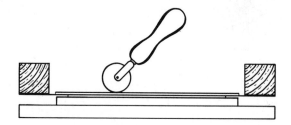

The screen must be gently rollered through clean newsprint in order to remove any excess moisture from the stencil film. The layers are (*from the top downwards*) newsprint, mesh, stencil film, mount, table surface.

Pre-sensitized films

Pre-sensitized films are both reliable and extremely easy to use provided that the manufacturers' instructions are followed carefully. The pre-sensitized film, as stated earlier, is manufactured as a sensitized emulsion coated on a polyester or vinyl base. It is a development from the carbon-tissue method and has the advantages of not

Exposing the indirect photo stencil film.

requiring sensitizing nor any of the time-consuming transference of film to temporary support associated with the carbon-tissue methods. The processing stages are cut down to exposure, development, washout, and mounting on the screen.

Exposure

The film must be processed in safe yellow light conditions for it is immediately sensitive when removed from its container. In addition, it should be handled carefully as any creases in the film will impair good adhesion to the screen mesh (obviously the screen is not involved during the exposure of indirect stencil film). The film should be cut approximately 4 cm ($1\frac{1}{2}$ in.) larger all round than the positive image so that during processing it can be handled by the edges without affecting the quality of the stencil image.

During exposure the emulsion side of the positive is always brought into contact with the backing sheet side of the stencil. Therefore the better stencil films are generally those with the thinnest backing sheets (2 mm rather than 5 mm) as they allow less reflection and refraction of light between the positive and stencil film emulsions.

light source

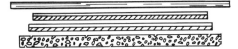

Exposing an indirect photo stencil using a sheet of plate glass and a piece of foam rubber. Layers (*from the top*): glass; positive; photo stencil film; foam rubber. Note that the emulsion side of the positive is in contact with the stencil backing sheet.

Developing

After exposure the film is generally developed in either the developer supplied by the manufacturer or a solution of hydrogen peroxide. The developer is an oxidation agent and serves to harden further the required printing areas of the stencil. The recommended strength of the hydrogen peroxide varies from one stencil manufacturer to another but is commonly between 0.5 and 2 per cent in a water solution. The solution should be mixed fresh every day as it will suffer rapid decomposition from exposure to light and, to a lesser extent, from dust particles settling into the solution. The use of distilled water will increase the active life of the developer. It is also advisable to wear rubber gloves when handling this developer and to use it in a well ventilated room.

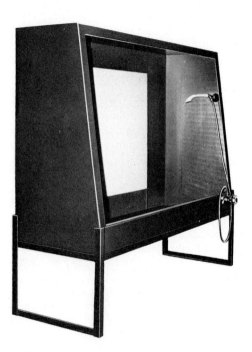

Stencil washout unit incorporating an illumination back panel (photograph courtesy of E. T. Marler Ltd).

Washout

The washout for the films already mentioned is performed either in a dish or against a sink backboard with a fine spray of warm water (45°–52°C., 110°–125°F.). It is washed until all the soft areas of the film are completely cleared, leaving only the hardened stencil areas which are then 'set' by lowering the temperature of the water until it is cold, and further washing it for $\frac{1}{2}$ to 1 minute.

After the initial seconds of washout the lights can be turned on to check the quality of the stencil. It is an advantage to have a backlit panel for this purpose.

A further variation on the indirect stencil is the sensitized non-developed film. This is the easiest of all to process as it is already sensitized and requires only exposure and washout before fastening to the screen. It has the added advantage of being a cold-water washout, which eliminates the frustrations of fluctuating temperatures due to inefficient mixer taps. The cold-water spray must be very fine and gentle and great patience should be exercised in order not to force the image and so run the risk of over-washing the stencil. It is the most expensive film stencil material and although it is of a very high quality and probably the most expedient it is also certainly the most temperamental. It requires correct storage conditions as it is very sensitive to temperature and humidity. All sensitized indirect films are best stored at a cool temperature of between 15° and 20° C. (59°–68° F.) and at a relative humidity of between 60 and 65 per cent.

Indirect stencils provide perfect mesh bridging.

Adhesion to the mesh

The washed-out stencil is placed emulsion side up onto a flat support which can be a sheet of board or glass but which must be smaller in dimension than the inner screen frame. The printing side of the damp screen is lowered onto the stencil and the excess moisture is progressively and gently blotted off with clean sheets of newsprint. This *must* be done gently – it is often mistakenly presumed that this part of the process is intended to impregnate the stencil into the mesh, which is not the case as an impregnated stencil will develop pinholes at the thread junctions and also produce saw-tooth edges in the imagery. If at this point a great deal of the stencil colour is transferred to the newsprint, this is an indication that the stencil has been underexposed or underdeveloped.

After blotting, the screen should be left on the build-up for a few minutes. (Some manufacturers recommend weighting the frame to increase adhesion but another school of thought considers that this will stretch the mesh

Indirect stencil on mounting board prior to screen contact.

Peeling the backing sheet away from the dry stencil.

into the stencil, causing retraction and consequential stencil disruption when the weights are removed.) If weighting is needed at all it is perhaps best to lay a sheet of newsprint on the inking side of the mesh and place a board of the same size as the build-up on top for a few minutes.

After these few minutes the screen can be removed and dried with a *cool* fan. Towards the end of the drying period and while the stencil is still moist the unwanted open areas around the stencil can be filled with screen filler.

When the stencil is finally dry the plastic backing film can be gently peeled away from one corner across the screen, but if there is any resistance to peeling, continue to dry the stencil.

There may occasionally be some evidence on the stencil of a residual film of the emulsion-to-plastic adhesive. This can be very gently wiped away with cotton wool dipped in screen wash.

THE DIRECT/INDIRECT METHOD

There is a third photo-stencil process which is a combination of the two types already discussed; this is known as the direct/indirect method. It combines all the advantages of the direct and the indirect stencil with the extra and most important quality of consistency from stencil to stencil. The direct/indirect process is a two-component one incorporating the very durable direct photo emulsion with the highly accurate indirect photo-stencil film.

In principle the direct/indirect method consists of placing the prepared screen, printing side down, onto the stencil film which is placed emulsion side up. The sensitizer or transfer medium is then squeegeed through the mesh on to the film with a round-bladed squeegee. In this way the indirect film becomes impregnated into the

screen and will then behave in much the same way as a direct emulsion and yet retain print sharpness through its good mesh bridging. When the emulsion is dry the backing sheet can be removed and the screen is ready for exposure. The exposure process is the same as has already been described for direct stencils. It is an advantage to use orange- or red-dyed mesh.

There are several variations on the direct/indirect method. Although the same in principle, they differ in both the method of application and the method of processing.

In some cases the film is stuck to a dampened screen with a squeegee stroke, at which point the sensitizer is squeegeed on. In another method it is the film that is pre-sensitized. The variations available on the market generally differ with regard to whether the emulsion film is pre-sensitized, stuck on by a sensitizer or sensitized after adhesion with a transfer medium.

The direct/indirect method is by far the best stencil method available. It is particularly useful to the artist in that it can allow the use of removable fillers on the stencil while retaining image detail and accuracy. However, in other cases its qualities may be far in excess of what is required: it is costly and has been developed to print in tens of thousands rather than in small limited editions.

It is most important when using photographic stencils, and direct/indirect stencils in particular, to read and attend to the manufacturers' instructions. It is also important to know the base of the stencil so that it can be de-coated after use and so that the appropriate fillers and inks are used.

LIGHT SOURCES

In general, screen-printing photo-emulsions are predominantly sensitive to ultra-violet light, therefore those light sources operating most intensely in the ultra-violet range are the most appropriate for photo-stencil production.

It is true, as in all aspects of the screen process, that it is possible to get by with cheap sources. The cheapest of all these sources is, of course, *direct sunlight* which, although sometimes unreliable, is inexpensive to use and ideal for some purposes.

Photoflood bulbs are also used at the do-it-yourself end of screen printing. They radiate little ultra-violet light and are consequently extremely slow. They, like the sun, cause a build-up of heat through the glass exposure frame and can cause damage to the emulsion if not used in conjunction with a cooling fan.

Mercury vapour high-pressure discharge lamps are an excellent light source for making photographic stencils. They

Carbon arc lamp and screen exposure unit (photograph by Andrew Folan).

PDR automatic metal halogen light source (400/800 watts output). (Photograph courtesy of Pronk, Davis & Rusby Ltd.)

are made from 125 watts rating upward to 2000 watts, but it is the 125-watt and 400-watt lamps that are the most commonly used and, depending on the size of stencils being processed, it may be necessary to have a number of lamps. These lamps are internally silvered and so do not need extra reflectors. They project a uniform light with a relatively direct beam, thus minimizing detail undermining. They must never be used directly through the mains but must always be installed with the correct control gear, i.e. the correct lampholder, ballast, capacitor, fuse and a double-pole switch. Reference must be made to the manufacturer with regard to the correct control gear and to the capacity of their lamps.

The mercury vapour lamp does generate some heat but does not need cooling during operation. It should, however, be ventilated when it is installed into a self-contained printing-down unit.

The lamp should be warmed up for approximately five minutes before the exposure is started, and it will not relight after being switched off until it has had a cooling-off period. The lamp will degenerate after a maximum of 1000 working hours, thus necessitating longer exposure for satisfactory stencils, but it should preferably be replaced at this point.

Black light fluorescent tubes. Black light is a synonym for ultra-violet light radiation between 3200 and 4000 angstroms, and is produced in special fluorescent tubes as a result of an internal coating which converts the light to the ultra-violet wavelength. These lamps do not get very heated during exposure and can consequently be used very close to the photo emulsion.

Until recent developments the *carbon-arc lamp* has been by far the best light source for photo-stencil work. It provides an extremely bright and consistent light from a singular point and has a high density in the appropriate wavelengths. This means that the stencil emulsion will reach its optimum hardness relatively quickly, thus eliminating the possibilities of detail undercutting from reflected light. The carbon-arc lamp is manufactured to different amp values. Its light source is produced from two unenclosed, electrically energized carbon rods that also give off smoke, peroxide dust and ozone, all of which are toxic. In some European countries, therefore, environmental regulations restrict the use of carbon-arc lamps, and the recently developed metal halogen lamps are generally preferred.

The *metal halogen lamp* is a development from the mercury vapour lamp and incorporates metal halides, mercury iodides and gallium iodides. It projects an extremely powerful beam from an enclosed source and not only does it not give off any toxic gases or dust, but it cuts down exposure times even in comparison to the carbon-arc lamp and emits very little heat.

CALCULATING THE EXPOSURE TIME

It is important to establish a basic working exposure for the type of light source and stencil material in use, as all variations can then be computed from this basic exposure. Any variation on the basic exposure will result from, firstly, a change in the distance from the light source to the print-down frame and secondly, a change in the type of positive.

It is a rule of thumb that the distance of the light source from the printing-down frame should be approximately equal to the diagonal of the positive.

The basic exposure is calculated by making a step exposure test at an established distance. (An even large-dot halftone clear film positive can be used for this.) The stepped variations are made in the same way as for a normal photographic test strip. The expected range of timings for different stencils can be gleaned from the manufacturers' instructions.

The first exposure (e.g. 30 seconds) is made on only one portion (say a tenth) of the positive, the next, which should include the first, is exposed for a further 30 seconds, and so on until the entire stencil has been exposed to a ten-step range from 30 seconds to 5 minutes. After developing, the stencil will show a stepped variation in the amount of emulsion swelling and image definition. At the exposure stage where the image definition is clear and no longer improving and where the emulsion can be seen to have stopped swelling, the basic exposure time is set. A step before this point leaves the emulsion too soft for good definition and a step after, too hard for good adhesion. It is an advantage when making this assessment to stick the stencil to the screen and actually take prints and gauge results.

Given this basic exposure as a constant it becomes a simple matter to calculate exposures to satisfy differing conditions, as the light intensity during exposure decreases as the square of the distance. The new exposure time for a shorter or longer distance can be calculated by the equation

$$\text{new exposure time} = \text{basic exposure time} \times \frac{(\text{new distance})^2}{(\text{basic distance})^2}$$

Compensation must also be made for the opacity of the positive when making film exposures. This is a simple matter of knowing the rate of light loss for varying positive types and compensating for it. Tracing paper, and special matt drawing films such as Permatrace and Kodatrace need an extra 20 to 25 per cent exposure. Sellotape needs about 12 per cent extra. Build-up layers of clear positives will require additional compensation – about 15 per cent for each layer.

It should be remembered that variations on this basic exposure are also due to an inconsistency of the light source and the photo-stencil preparation (e.g. an extra coating on a direct stencil is going to need increased exposure of 8 per cent).

Further compensation must be allowed when using red- or orange-dyed mesh in conjunction with a direct or direct/indirect stencil. This is due to the absorption of the light rays into the mesh. An increase of at least 50 per cent exposure time is recommended. Temperature and humidity will also slightly affect exposure. Coarser, heavier meshes will also need to be compensated for in direct-stencil production. A mesh that is twice as coarse as for the basic exposure needs a 50 per cent increase.

When exposing indirect photo stencil films it is essential to achieve the correct exposure. An underexposed film will adhere to the screen extremely well but with poor definition while an overexposed film, although showing good image resolution, will have very poor adhesion.

It is also extremely important to be aware of the dangers involved in the use of exposure light sources, the greatest being to the eyes from the ultra-violet light. The operator must ensure that his eyes are never directly exposed to the light source and that sources such as the carbon-arc lamp are in a well ventilated room. (This is more fully dealt with in Chapter 13, pp. 161–62.)

RECLAIMING AND DE-COATING OF SCREENS

The chemical agents used to reclaim and de-coat the photo screen vary according to the type of photo-stencil film in use. The process can be as simple as a strong spray with water, as in the case of Autostar indirect stencil film; on the other hand, strong specialized pastes may be required for use in conjunction with high-pressure spray machines.

The function of the de-coating agent is to oxidize the emulsion in order to make it water-soluble. Generally speaking, the indirect films are the easiest to de-coat while the direct and direct/indirect stencils, which have been chosen for their durability and are impregnated into the mesh, are far more difficult to remove.

Before attempting to de-coat any screen it is essential to remove all residues of ink (at least from one side of the screen) with the appropriate solvent as inky residues can create a barrier to both the de-coating agent and the water spray. Either a 20 per cent solution of caustic soda or one of the proprietary pastes will help in the final removal of any traces of fat left in the mesh. The correct de-coating agent is then thoroughly brushed onto the emulsion and

allowed sufficient time to do its work. It is important to consult the stencil manufacturers' instructions with regard to the correct de-coating agent. Most stencils which are predominantly based on P V A will be affected by dilute chlorine bleach or oxalic acid, whereas gelatin-based stencils will need to be left in a double-sided coating of enzyme powder before being sprayed.

Direct stencils which have been manufactured for better mesh bridging, detail accuracy, and durability will require stronger de-coating measures because they achieve their superior qualities through the addition of further emulsion chemicals, some of which are water-resistant. There are special pastes and compounds which will help in the removal of the more complex direct stencils but with these stencils there is no substitute for the additional use of a high-pressure water unit which will blast any emulsion residue, and indeed any residual ink, from the screen, rendering it perfectly clean for processing the next stencil. In fact if the workshop does not include a high-pressure water pump it would be folly to use such complex stencil material at all.

For certain work it may be more economical to use one highly durable photo stencil from which several colours can be printed by the application and removal of fillers (cellulose or otherwise) than to make a new photo stencil for each colour even if the screen mesh eventually becomes impossible to reclaim and has to be dumped.

Some stencils will prove so resistant to de-coating that it becomes necessary to abandon the screen mesh after use. This can be due to extreme hardening from either over-exposure or a chemical reaction between the emulsion and the type of ink in use.

It should be noted that the de-coating agents can also have an adverse effect on the mesh, but this can be neutralized by a wash-over of 5 per cent acetic acid before the final washout.

It cannot be stressed enough how important it is to consider fully the degree of detail and durability required in relation to the studio set-up and equipment, before choosing which photo-stencil material to use.

Finally it must be stated again that it is always essential to read and abide by the stencil manufacturers' instructions in order to achieve the best results. When in doubt always consult the manufacturer.

10 Inks and printing stock

The remarkable versatility of the screen-printing process, in terms of the number and types of surfaces it is capable of printing on, has given rise to an equally impressive range of associated inks. The inks that have been used in screen printing range from paint (which was used in the early days before ink manufacturers became involved) to the electrically conducting inks that are used today for the production of printed circuits. It is still possible to adapt other types of printing ink and paint to the screen process but this is pointless as nearly all qualities that are necessary in ink are covered by the ranges of ink already in production. This chapter will tend to deal mainly with conventional inks and printing papers.

INKS

The qualities required from a printing ink are threefold: that the pigment is sufficiently finely ground to allow the passage of ink through the screen mesh, that it does not dry in the screen during printing owing to over-fast evaporation and that it will respond to both the squeegee and the stencil to provide sharp and accurate printing.

The screen-printing process is traditionally renowned for the thickness of its ink deposit and for the opaque boldness of its colour, although a heavy deposit of ink is simply the natural result of a stencil process such as screen printing, and the opacity and boldness of colour are largely a consequence of this thickness of ink deposit.

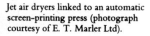

Jet air dryers linked to an automatic screen-printing press (photograph courtesy of E. T. Marler Ltd).

This lingering idea of screen-print quality has, however, long since been superseded by developments in the ever-growing screen-process industry: there are now inks in production that are capable of being printed to a quarter the thickness of former ink deposits and yet still retain a considerable degree of opacity. In complete contrast, the use of extender base makes it possible to print inks at any degree of transparency. Screen printing is now reaching the point where it can not only emulate other printing processes but in some respects can also compete with them commercially.

The higher industrial levels of screen-printing operational technology and chemistry are beyond the scope of this book but there are benefits that can be derived (especially from manufactured inks) and passed on for use in even the most rudimentary of screen-printing set-ups.

Oil-based inks

Screen inks were originally developed for the production of outdoor posters, so they are usually very durable and relatively light-fast, although this is not the case with the cheaper varieties which are mainly used for short-life posters. The normal ranges of inks used for screen printing on paper and board are oil- or cellulose-based. Oil-based inks were the first to be developed in the screen-printing industry; they print to a matt finish and are produced in a wide range of colours which usually includes extender base and fluorescent colours. In addition to these there is a range of oil-based gloss inks which unfortunately have the disadvantage of requiring hours of drying time. For this reason an overprinted varnish is frequently used to give matt inks a gloss effect; alternatively, the range of modern cellulose-based or vinyl-based gloss inks can be used.

Thin-film inks

Thin-film inks are now the most commonly used in conventional screen printing. They are made from finely ground pigment and should be thinned with white spirit, to give a brilliant matt opaque printing result. Normally they are produced in a range of colours numbering from 20 to 50, depending on the manufacturer, and while they are not manufactured with the idiosyncrasies of the fine artist in mind, they will, with skilful mixing, produce almost any colour that might be desired. The range of possible colours and colour qualities is greatly enhanced by the addition of extender base, fluorescent, trichromatic and metallic inks, all of which will happily blend with the standard thin-film range.

The term 'thin film' is really only a relative one as the deposit of ink, although half the deposit thickness of

former screen inks, is still 15 to 20 times the thickness of
ink film resulting from the lithographic printing process.

Ultra-thin-film inks

Ultra-thin-film inks were developed to keep pace with
the demands of the ever-increasing use of automatic
screen-printing machinery, which requires a much thin-
ner ink deposit to allow more rapid ink drying and print
stacking. These demands were met by incorporating into
the ink faster evaporating solvents and special resins to
help release these solvents more rapidly. Ultra-thin-film
ink will print a deposit which is half the thickness of the
standard thin-film ink. It is suitable for hand-operated
presses provided that the correct thinners are used and
will resolve very fine halftones consistently. Retarders
may also be used but not too liberally. The ink suppliers
should be consulted with respect to the correct thinners
and retarders.

Extra opaque inks

In addition to the ordinary oil-based and thin-film ink a
range of heavy opaque inks is available for use in screen
printing. Produced in a wide variety of colours, they are
used for printing very thick deposits of fully opaque ink,
making them particularly useful for obliterating printing
errors to the point of almost allowing a complete restart.
Also, they can be mixed into thin-film inks in order to
increase the pigmentation.

Extender base

Extender base is a transparent medium that can be added
to screen ink in order to reduce its opacity. The use of
transparent inks also allows the possibility of producing a
third colour from two overlapping printed colours, up to
seven colours from three overlapping and so on. If exten-
der base is overprinted on its own it has the effect of very
slightly reducing the tone of any colours underneath. A
minimal addition of either white or black to the extender
base will provide a method of making tonal corrections
when overprinted onto previous colours. Ink mixes that
contain extender base are smoother and therefore more
easily printed under the squeegee pull.

Metallic inks

Ready-mixed gold and silver metallic inks are produced
by many screen-ink manufacturers. They are particularly
successful as screen-printing inks because the thick ink
deposit contains vastly more metallic particles than do
metallic inks for other printing processes and conse-
quently allow more light reflection which, of course,

influences the richness of the metallic quality. It is also possible to buy ground metallic powder which can be mixed into the extender base in varying quantities to produce different densities of metallic quality. Bronze, copper and other metallic powders are also available and all these powders can be mixed in with screen inks to produce metallic effects in a colour base.

Fluorescent inks

At one time fluorescent inks were used exclusively within the province of screen printing. Subsequent developments in pigmentation have led to the successful application of fluorescence to other printing processes. The advantage with screen printing lies again in its ability to print an extremely thick deposit of ink, which in the case of fluorescent inks provides a considerably longer light life. These inks are most effective when they are printed on a white background with a dark surround.

There is a wide variety of fluorescent screen ink available: the colours are mainly akin to the primary range and they will mix to great effect with the standard inks in the same range.

Trichromatic inks

The trichromatic inks, including black, have been developed for use in printing four-colour separations (Chapter 8, p. 90): they are a transparent variation on the primaries – red, blue and yellow – and are magenta, cyan, yellow and, fourthly, trichromatic black. The four colours are carefully balanced to render the full colour range when used in conjunction with the four-colour separation process, but despite this they will mix readily and effectively with the other colours in the same range. As they are very finely pigmented they are consequently very easy to print with.

Varnish

There is a wide range of varnishes available from screen-process suppliers, and while they are most commonly used to give a gloss effect to matt screen inks by over-printing they also increase the weatherproofing on material that has been printed for outdoor use. These varnishes vary considerably in their drying times (from as little as 1 hour to as much as 8 hours) and the quality of varnish is also very variable: some are yellowy when printed and others yellow with age. The best varnishes are permanently clear. It is, therefore, wise to check with the manufacturers as to the clarity and durability of their products before making a purchase. Varnishes are usually very strong inks and must be thoroughly cleaned from

the screen while still wet. As they are clear it is very difficult to ascertain when the varnish has been totally removed from the screen. It is almost impossible to shift some varnishes once they have dried into the screen.

Gloss inks

Apart from using varnish to achieve a gloss effect there are some ranges of gloss ink on the market, including the slow-drying oil-based gloss inks already mentioned, plus cellulose and vinyl-based gloss inks developed for printing on both paper and plastic. They are produced in only a limited range of colours, are very smooth to print with and in some cases are self-solvent on the screen during printing. They are, of course, specialist inks requiring special thinners – so full attention should be paid to the manufacturers' recommendations for their use.

Water-based inks

Water-based screen inks were, at one time, manufactured in quantity but they present so many problems in screen printing that it is now unusual to come across them. They are antipathetic to most stencils (both manual and photo), they print unevenly on sized paper owing to uneven rates of absorption in the paper, and they will cockle and shrink other papers. If however a low-sized absorbent-quality paper is used the water-based ink will soak into it to produce a quality of printing not normally associated with the screen process.

These inks can be made from mixtures of pigment or dyes in gum solutions or even cellulose wallpaper paste.

Universal tinters

Tinters are highly concentrated colour that can be mixed with extender bases or inks to produce printing colours or colour changes.

Scratch and sniff inks

There are screen inks available which incorporate smells into their molecular structure. The inks are printed normally and when dry the odour is released by scratching the ink surface.

Specialist inks

In addition to the conventional screen-printing inks, there are numerous specialist inks for printing on diverse surfaces (see Chapter 12), many of which will print, or are adaptable for printing, on paper. When choosing such an ink great care should be taken to ensure that it is appropriate for the stencil, the mesh and the printing stock. The

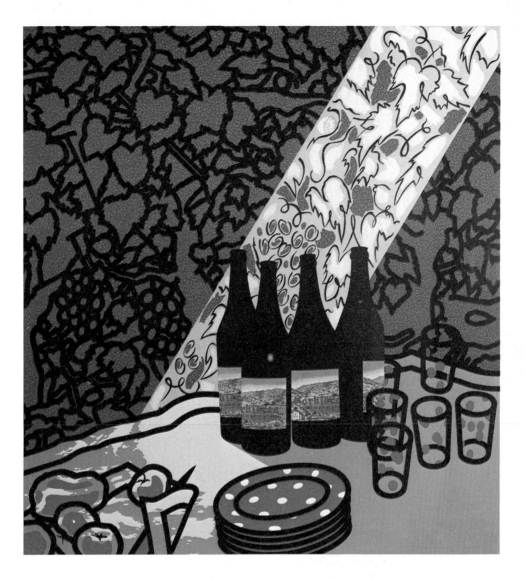

Patrick Caulfield, *Picnic Set*, 1977, image size 95·9 × 90·5 cm on Arches paper. Published by the Waddington Gallery, London, in an edition of 100. Screen printed using photographic, hand-cut and Kodatrace stencils. The dotted background was printed from a hugely enlarged letraset photo stencil and the black outline from a hand-painted Kodatrace stencil. The wine bottle labels were screen printed using the conventional four-colour separation process. 12 printings, printed by Kelpra Studio Ltd.

THE TUAREG

solvent in certain cellulose-based inks can have an adverse effect on hand-cut stencils stuck with solvent. This effect can only be properly avoided by altering the stencil or the ink. The correct thinners and retarders must always be used because defects in printing quality through chemical incompatibility can even occur after a print is apparently set. Intermixing of ink types should also be avoided for this very reason and overprinting of different ink types must also be avoided, for incompatible layers of ink can separate from one another and literally fall away from the print.

It is always advisable to keep different ink ranges entirely separate as intermixing of types is usually impossible and therefore wasteful.

Mixing ink solutions

When mixing ink and thinners the proportion of thinners should be about 20–30 per cent of the mixture. This is, of course, variable and depends on the desired printing quality, the type of ink, the type of stencil and the quality of the mesh; it is only experience that will enable a printer to mix ink exactly to his requirements.

The ink mentioned so far contains drying agents that dry the ink through evaporation, so a well-ventilated studio will help in the print-drying process. (It is not advisable to use hot air to dry ink as this is liable to make the ink brittle and also adversely affect the printing paper, causing it to change size thus leading to registration problems.) Each layer of ink must be fully dry before applying the next, for otherwise drying time not only drastically increases but the stencil is in danger of damage during printing, owing to tacky ink.

Finally, with regard to colour, most ink manufacturers offer a service for matching colours to a customer's needs, and though this is fairly expensive, in certain cases it is indispensable. A minimum order of 5 litres (just over 1 gallon) is usually required.

PRINTING STOCK

Printing stock is the general term used to describe the material upon which the print is made, which in the main is paper, but in screen printing the stock can seem almost limitless. This section will deal almost exclusively with paper as printing stock.

The paper used for printing should be chosen with great care because it can not only be unsuitable for the type of stencil in use but it can also have a significant influence on the printing quality of the inks. For this reason it is important to know something of the variables concerned in the paper-making process.

Opposite: Peter Blake, *The Tuareg*, 1972, image size 25.8×13.4 cm on J. Green paper. Published by the Waddington Gallery, in an edition of 125. Screen printed from an original watercolour using a four-colour tonal separation system perfected by Kelpra Studio Ltd. Each colour is separated in three tonal stages and printed in the appropriate trichromatic ink, which is mixed to three different strengths by the skilful addition of matting base (an extender base with a matt finish). An extra black was used to print the two words. 13 printings, printed by Kelpra Studio Ltd.

Beating the pulp (photograph courtesy of Wiggins Teape Ltd).

Pulp

All papers and boards are manufactured from cellulose fibre pulp of vegetable origin, and the characteristics of different papers vary according to their pulp origins and their individual manufacturing processes. In theory, virtually any plant can be used for the manufacture of paper but in practice those commonly used come under the general classifications of seed hairs (cotton), bast fibres (flax jute hemp), wood fibres (deciduous and coniferous woods), leaf fibres (esparto and manilla) and grasses (straw). Combinations of these fibres are often used to produce particular paper qualities. Waste paper is also graded and recycled to produce further papers.

In industry the number of raw materials used to produce paper is limited by the ability of each material to undergo the bleaching process and yet retain its fibre strength.

Wood is by far the commonest raw material used in this country for producing paper, and although deciduous woods are used, coniferous wood, particularly spruce, is the commonest pulp source.

The raw materials are reduced to pulp almost exclusively by chemical means. The material is shredded and digested by an acid or alkaline process in order to free the cellulose fibres from the rest of the vegetable matter. There is also a mechanical process (used mainly with spruce) in which the wood is actually ground down into pulp. This mechanical wood pulp is a cheaper product than chemically resolved wood pulp and is used in the manufacture of the cheap lower-quality papers such as newsprint.

The pulp is subjected to a bleaching process in order to make it as white as possible without undermining the strength of the cellulose fibres, and is then further refined by the beating process, which literally beats the mixture of water and pulp into shape for the remainder of the

paper-making process. Controlled use of the beating process actually determines the final quality of the paper product. The cellulose fibres are water-forced for greater density, fibrillated for bonding strength or chopped for absorption properties. Paper sizing (with gelatin and alum) can also take place at this part of the process to give ink reception qualities and some moisture resistance.

Paper-making machines

The three basic machines for making paper – the Four-drinier, the MG machine, and the cylinder mould machine, all use a fine wire mesh to drain the water from the pulp, which is then processed through the machine. The Fourdrinier is the most widely used paper-making machine, and is capable of draining the pulp and running it through a series of rollers culminating in a roll of paper ready for cutting into sheet sizes. The MG (machine-glaze) machine, also known as the Yankee, varies from the Fourdrinier in that drying is carried out on one enor-mous, highly polished cylinder as opposed to several smaller cast-iron cylinders. This drying system produces a paper that is glazed on one side.

The third machine is the cylinder mould machine which is responsible for the manufacture of the high-quality mould-made papers and boards which most closely correspond to hand-made papers. 'Board', in this sense, refers to any paper that is more than 90 lb. in weight or 220 grams/sq. metre (gsm). The cylinder machine also produces strawboard and cardboard.

Paper being reeled off the machine (photograph courtesy of Wiggins Teape Ltd).

A coating machine, which is used to produce coated art, cartridge and label papers (photograph courtesy of Wiggins Teape Ltd).

Machine-made printing paper is improved during its manufacture by finishing processes such as calendering and coating, which improve both the surface quality and the appearance of the paper.

Calendering consists of sending the paper through a vertical series of rollers which are arranged to alternate between a chilled polished iron and a cotton surface, giving the paper surface qualities that are commensurate with good printing.

Papers requiring a high finish for fine detail printing are coated prior to calendering. A finely ground mineral pigment, known as 'loading', is added to the paper during manufacture in order to fill in the grainy paper surface and bring the entire surface of the paper up to the same smooth level. Calendering or 'super-calendering' (calendering performed separately from and extra to the normal machine calendering) compresses the coating to produce a high finish. Coating can be an incorporated function of the Fourdrinier machine (resulting in a thin coating) or be made with other off-machine processes.

Types of paper and board

All papers can be printed on by the screen-printing process but, as previously stated, care must be taken to select the appropriate paper for each job. It should be remembered that the description of paper as of either high or low

quality is only an academic qualification, and in fact every paper has its own characteristics that set it apart from the others. Papers range in quality from newsprint through coated papers to the purest hand-mades.

Newsprint is made with a high proportion of mechanical wood pulp and is therefore well off-white, not durable and yellows rapidly with age. It is normally used in short-life publications but is an indispensable all-purpose workshop paper for both proofing and cleaning up.

Pure or wood-free printing paper is a description that covers a range of quality papers that have been specially developed for printing processes. (The term 'wood-free' means that the paper is free of mechanical wood pulp.) Such paper is loaded with mineral filler which increases its opacity and brightness, and is strong and light-fast.

Coated papers are coated by a number of off-machine processes such as brush, air knife, trailing blade and cast coating, finishing processes which are more controlled than the machine-incorporated processes and can therefore be more precise. In fact the full range of paper, from mechanical wood pulp to wood-free, can be coated off the machine and subsequently super-calendered to produce very specific paper qualities.

Cast-coated papers have been given an off-machine coating process that is similar in operation to the MG machine: it produces a very high-gloss paper which is nevertheless absorbent as it is not super-calendered to compress the pigment. The result can be patchy printing, however, if the inks are not carefully chosen.

Developments in the paper industry have brought about *plastic-coated paper* and board that are excellent for screen-printing detail work as they have a hard, non-absorbent, even surface. It is even possible, to a certain extent, to wipe unwanted ink off this paper without damaging it.

Cartridge paper is the paper that is used universally by artists for drawing. It is wood-free and hard-sized to facilitate drawing ink and is also a fairly good-quality printing paper.

Machine-glazed paper, produced in the MG machine, is very economical for posters and makes a good proofing paper for screen printing.

Art paper is super-calendered wood-free paper coated with china clay pigmentation, used largely for gravure printing in glossy magazines.

Antique paper is a matt paper that is usually off-white to cream in colour. It is made from deciduous wood or straw pulp and is recognizable by its ingrained parallel line markings.

Filter, blotting and duplicating paper are all produced for their absorbent qualities, although duplicating paper does contain some size to prevent ink spreading. Filter paper is chemically inert.

As previously mentioned, *mould-made paper* is made in the cylinder mould machine which is also responsible for cardboard and strawboard; in fact most mould-made paper is substantial enough to qualify as board. It may be smooth or rough or, in some cases, textured. The best mould-made paper is made from rags and is used as a substitute for hand-made paper. It can be very absorbent, depending on the sizing, but it does give splendid colour resolution. It is extremely durable and light-fast.

Hand-made paper is traditionally regarded by artists as the very best of all papers. Each sheet is made individually from 100 per cent rag (usually cotton – often the white offcuts from textile mills) on a wire gauze mould incorporating a deckle, and is dried on felt. It is very expensive but it is strong, light-fast and gives excellent colour resolution. Most hand-made papers contain size and are often finished to produce a printing surface.

It is, of course, possible to make paper oneself, and there are several books available on this subject (see the reading list on p. 167).

Although mould-made and hand-made papers are regarded as top-quality papers, they are not necessarily the best suited to screen printing. It is difficult, for instance, to control very fine detail on hand-made paper: a harder surface is always more suitable. They do, however, give the best colour resolutions and brilliance.

Over and above the main categories of papers mentioned here there are countless papers developed for the wrapping and stationery industries (e.g. glassine, parchment, tissue and greaseproof) which are bound to be useful to an artist somehow. All these papers will accept screen ink of one type or another.

There are countless other materials, many unexploited, that will also accept the screen-printing process.

The conditioning of paper

The drying and reeling processes during paper manufacture subject the paper product to a range of extreme pressures and strains, which, without factory conditioning, can render the paper unmanageable after its first exposure to humidity. The conditioning process consists of unreeling the paper in an area of relatively high humidity and re-reeling it without roller tension. Care must still be taken to ensure reasonable temperature conditions in the printing room as the factory conditioning process is not perfect.

PAPER SIZES AND WEIGHTS

During the last few years paper has been manufactured almost exclusively in metric sizes, the main series being the A series, which has replaced the traditional paper sizes

such as foolscap, imperial, crown, royal and demy. The A series was instigated by the British Standards Institution in order to bring British paper sizes to a rational system in line with other European countries.

The A sizes are designed so that the ratio between the long and the short side is a constant throughout the series (1:1.414. This means that each size is a proportional enlargement or reduction of any other size. The advantages for reproduction camera work are obvious.

The standard size is A0 which is 841 × 1189 mm. This size is 'halved' to arrive at the next size down – that is A1, which is 594 × 841 mm. The short side of A0 becomes the long side of A1. And so the series system goes, right through to A7.

Relative paper size. Each size is exactly half the next size up.

'A' SERIES	A0	841 × 1189 mm
	A1	594 × 841 mm
	A2	420 × 594 mm
	A3	297 × 420 mm
	A4	210 × 297 mm
	A5	148 × 210 mm
	A6	105 × 148 mm
	A7	74 × 105 mm

Consequently 2A would be 2 × A0 (1189 × 1681 mm). Running parallel to this is the RA series, the sizes of which are slightly larger than the A series to allow trimming to A series size. The SRA sizes are slightly larger again to allow both bleed and trimming to A sizes.

There is also a B series which represents the intermediate sizes of the A system. It too is proportional (1:1.414) and allows reduction and enlargement between series.

'B' SERIES	B0	1,000 × 1414 mm
	B1	707 × 1000 mm
	B2	500 × 707 mm
	B3	353 × 500 mm
	B4	250 × 353 mm
	B5	176 × 250 mm
	B6	125 × 176 mm

In addition to the metric size series for paper there is also a series system for paper weight.

Paper weights were previously expressed as a multiple of pounds per ream in order to denote the substance (i.e. the thickness) of the paper. This led to considerable confusion as exactly the same paper substance was expressed by different numerical qualifications for different dimensional sizes of the same paper.

Paper weight, and therefore substance, is now expressed as grams per square metre (gsm), which ensures that the same paper always has the same weight qualification regardless of its dimensional size.

Some hand and mould made papers are still manufactured to traditional sizes and still have their substance expressed as lb./ream.

11 Printing and registration

PRINTING

In simple terms screen printing is a matter of pulling ink, under pressure, with a rubber blade across a stretched screen and, in so doing, depositing an image through the open spaces of the screen stencil onto the printing stock. In practice, however, screen printing is a much more complicated and unpredictable process.

Here it will be assumed, in order to include the maximum information, that the aim is consistently to print the finest detail to the greatest quality over the largest edition size. Obviously the printing of less detailed work is not going to present as many problems, either in printing or in registration, and, although the same methods are appropriate, such stringent precautions will not be required. It will also be assumed that a factory-made vacuum press is in use.

The essence of consistent printing lies in being able to print to a controlled rhythm at speed; the finer the detail the more essential the speed.

Before starting, the printer must ensure that everything he may require during the print run is ready to hand so that his printing can become a continuous and consistent movement. Any delay during the printing process will cause ink to dry into the stencil.

The printer should have proofing paper, clean rags, ink, palette knives, solvents, activators, tape and some small pieces of card readily available so that any interruption during the printing process can be dealt with efficiently.

The printing stock should be placed on a table on one side of the press and the drying rack on the other, to enable the printer to establish an efficient working rhythm: paper from table to press to rack, from table to press to rack, and so on.

Usually when the stencil is printing well it will continue to print well as long as the process is kept constant.

During printing all equipment should be kept free from stray ink. This includes the outside of the ink container, the squeegee handle and as far as possible the insides of the screen frame. Most important of all, the printer's hands must be clean: it does not take a messy printer very long to soil his prints with unwanted ink.

The squeegee should be taped along both of its sides where the rubber meets the wood, to prevent ink from

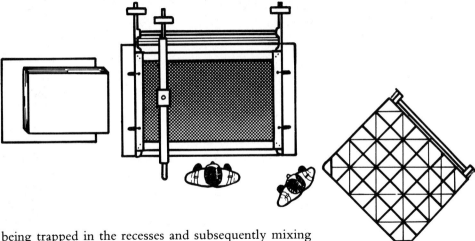

being trapped in the recesses and subsequently mixing into the ensuing colours. The squeegee must also be at least 4 cm (1½ in.) wider than the stencil on both sides.

The help of another person, to rack each print while the printer is registering the next sheet of paper, can reduce the time between each squeegee pull to almost half and so prevent ink from drying into the finer detail of the stencil.

Screens are generally rectangular and are mounted on the press with the long sides to the back and to the front. When the screen has been attached to the press the counterbalancing weights must be positioned to ensure that the screen will remain down during printing and stay up after each print has been taken. The hinge stop is then adjusted to allow the screen to rise only the minimum comfortable distance for feeding and positioning the paper onto the press bed. If this distance is too great there is a risk that the ink will flow back over the stencil during paper placement, causing unwanted ink to seep through and spread underneath the stencil.

The screen mesh must not be in contact with the printing stock on the surface of the press as, during printing, ink would bleed on to the underside of the stencil and cause the paper to stick to the screen. This, coupled with the action of the vacuum, can at worst detach parts of the stencil and at best produce furry-edged, 'swirl-marked' prints.

On a well-stretched screen there should be a gap of approximately ½ cm (⅜ in.) between the mesh and the press surface. This, which is known as 'snap', 'off contact' or 'lift off', is achieved either by adjusting the appropriate parts of the press or, lacking these, taping or pinning the requisite build-up of card to the undersides of the screen frame. The purpose of snap is to allow the stencil to free itself progressively from the printed paper as the squeegee is pulled across. Too much snap will create incomplete and unsharp printing, and will also place undue wear on the screen mesh from harsh contact with the two squeegee corners. The correct amount of snap is proportional to the tension of the screen mesh.

If the press is fitted with an automatic switching mechanism for the vacuum this will have to be adjusted before printing. The mechanism is usually a cam attached to the hingeing axis of the press, and should be set to turn the vacuum on while the screen is down and off while it is in the raised position.

Finally, all movable and adjustable parts of the press have to be checked and, where necessary, tightened. This is to prevent any 'play' which could cause registration anomalies during printing.

The press is then switched on and the printing is ready to begin. The next move is to register the paper to the screen stencil (this is dealt with later in this chapter under 'Registration', p. 140).

When the paper has been positioned in register on a vacuum press all the spare suction holes still visible must be covered to allow the vacuum maximum effect.

There are two directions in which the hand printer can pull the squeegee – either from side to side or from the back to the front. Side pulling has the advantage that, on a long horizontal image, a narrower squeegee can be used and therefore a more even pressure can be applied. However, it has the disadvantage that every time the screen is raised the ink reserve flows towards the back of the screen and has to be frequently retrieved with a piece of card. Forward pulling has the opposite advantages and disadvantages to side pulling, in that, although the ink is controllable, it is extremely difficult to apply an even pressure towards the middle of a very wide squeegee when printing.

The most important point is that whichever direction is chosen for the squeegee pull it must be adhered to throughout the edition: no matter how well a screen mesh is stretched on the frame, there will always be a relative degree of image stretch as the squeegee is pulled across the mesh surface. The pressure applied to the squeegee for each pull should also remain constant throughout the printing of the edition.

While the screen is in the flat position the ink is poured in a narrow column along the side of the screen where the squeegee pull is expected to finish. It should be poured onto the edging filler and tape and not onto the open areas of the stencil as it will then seep through to the printing stock. A modest amount of ink should be used because it is more controllable during printing and therefore less likely to mass in the screen corners and stray onto the inside of the screen frame, causing leaks and delays. Also some ink mixtures, particularly those using extender bases, tend to print certain constituent parts more readily than others (the base before the pigment), causing very slight colour changes through the edition. The use of a moderate amount of ink, occasionally augmented from the ink container during the print run, will maintain a

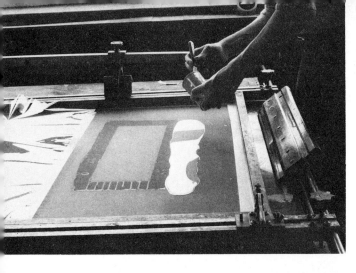

Pouring the ink onto the screen.

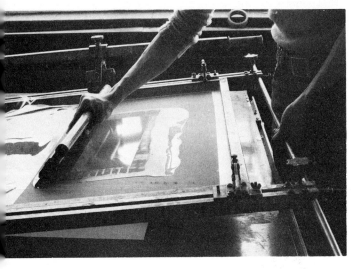

Charging the stencil with ink.

Correct action during printing: the ink is pressed through the screen stencil onto the paper.

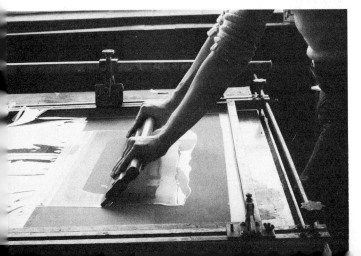

Taking or pulling the print.

consistent colour hue, and has the added advantage that should the colour or the registration prove inaccurate after the first proofing pulls then all can be righted without a major cleaning-up job.

After the printing ink has been applied the screen is raised a few inches from the printing surface and the stencil is 'charged' or 'flooded' with ink, which means that the column of ink reserve is pushed across the screen with the squeegee to the opposite side, leaving in its wake a thin layer of ink that has been absorbed into the stencil. It is mainly this layer of ink that is printed when the actual squeegee pull is taken.

When flooding the stencil the ink reserve is best pushed across the screen with the squeegee at an angle of 45° to the screen from the printer, rather than at 135° away from the printer. This will ensure a thin layer of ink in the stencil and so prevent ink seeping through to the underside of the screen before the printing pull can be taken. It will also ensure that the printed layer of ink is not too thick. However, remember that for many jobs a thicker layer of ink is required, and so what would be regarded as wrong in one case becomes desirable in another.

The screen is then lowered to meet the paper. The squeegee is placed behind the ink reserve and pulled, at a relaxed speed, under pressure, across the screen, well past the stencil to the opposite side. The squeegee should be held at an angle of approximately 45° and the pressure must be even and constant throughout the pull. Incorrect angling of the squeegee will cause either skidding, if the angle is too obtuse, or incomplete stencil image printing (from insufficient pressure) if the angle is too acute. Beware of relaxing pressure towards the end of the pull – this causes distortion in the printed image. 'Juddering' or hesitant squeegee pulling is to be avoided also, as it will manifest itself very clearly in the print.

The pull is complete when the paper has been observed to snap away from the mesh under the influence of the vacuum. Then, with one hand, the screen can be raised a few inches. The squeegee is pushed an inch or two backwards, but not as far as the stencil, thus releasing it from the ink reserve and allowing it to be rested against the frame at the back of the screen, without the risk of excess ink dripping onto the stencil area.

The screen is then raised, cutting out the vacuum and releasing the printed sheet of paper for racking. The next sheet is placed into register position and the screen is lowered to within a few inches of the printing surface. The stencil is charged with ink as before, the screen is fully lowered and the next print pulled. From here it is a matter of establishing a working rhythm and repeating the process throughout the edition. Several proof printings, followed by press adjustments, may be necessary before the optimum print quality is achieved.

Printing the image should require only one squeegee pull: two pulls will strengthen the colour and increase the thickness of the printed layer of ink, which, of course, may be desirable and consequently justified. The stencil image should not, however, be printed in two different directions on the same sheet of paper as this will cause the image to fall in two very slightly different places, creating soft edges and misregistration. It will also allow ink to offset on to the underside of the stencil which, in the case of an indirect stencil, may risk pulling it off the mesh during subsequent printing.

Some printers charge the stencil with ink after, rather than just before, the print pull, to minimize the possibility of ink flowing back over the stencil while the screen is raised. This is only advisable, however, with very open stencils as the inevitable delay between the registration of each sheet of paper will involve the risk of the ink drying into parts of the stencil.

SCREEN-PRINTING PROBLEMS AND REMEDIES

'Drying-in' and 'bleeding' are the greatest enemies of the screen printer, and it is with these twin evils in mind that all screen printing is organized. Drying in, as its name suggests, describes the condition when ink dries into the finer areas of the stencil, amalgamating with it and preventing further ink from passing through and achieving a full image on the printing stock. Drying in can be the result of many factors, several of which have already been noted: interruptions in the printing rhythm will allow ink to dry into the stencil; thick ink will dry into the screen more readily than thinner ink; over-warm printing conditions will cause ink to dry very rapidly; in some ranges of ink certain colours are more liable to dry than others owing to variations in the pigmentation and constituent ingredients – e.g. white in the conventional gloss and matt oil-based screen inks.

Drying-in can be prevented by the use of retarders, which should be used carefully and according to the manufacturers' recommendations, for if there is one thing more infuriating than a dried-in screen stencil it is a rackful of non-drying prints. Over-retarding will also reduce the quality of the printing ink.

Dried-in stencils can be cleaned most efficiently by first wiping them with a rag charged with screen-wash, followed about half a minute later with a dry rag. Screen activators, usually in the form of an aerosol, will also re-prime a dried-in stencil and when sprayed on to the blocked screen will loosen the ink and allow printing to continue. Several proof prints will then have to be taken to re-establish full printing quality.

Screen-wash and activators should be used under fully ventilated conditions, and protective rubber gloves must be worn when handling screen-wash.

Bleeding, the other major problem in screen printing, can be caused by over-thin ink, over-thin stencil, over-flooding, ink seepage through the stencil, insufficient snap and, conversely, excessive snap. It is remedied firstly by adjusting ink, stencil or snap, and secondly by taking proof prints, without charging the stencil with ink, until it clears.

Before racking each print it is essential to check it for leaks, which generally occur along either the edge of the stencil or the edge of the screen, and are most effectively dealt with by taping the appropriate section of the under-side of the screen. For this Sellotape, being thinner, is preferable to masking tape as it causes less interference to the work of the squeegee blade.

While printing through an edition there will inevitably be some spoils from bad printing – bleeding, filling in etc. Depending on how large and how complex the edition is likely to be, as much as 10 per cent or more should be allowed as spoilage. The spoils need not be wasted, as they can be used for colour and registration testing rather than risking an unspoilt print for this purpose. Newsprint or any other cheap paper should also be kept available for proofing and stencil cleaning.

Static electricity

Atmospheric conditions, in conjunction with the type of ink, stencil, printing stock and squeegee can all contribute towards the setting up of static electricity while printing. 'Static' manifests itself as a slight electrical shock each time the rack is touched, as streakiness during printing or as the stock sticking to the stencil, but it can be overcome by using antistatic sprays or fluids and, in the case of the rack, by earthing.

Printing with trichromatic and extender-based inks

Trichromatic and extender-based inks are very easy to print with as they are less liable to dry in the screen, better for detail, and easier to clean up, but caution is advised. An uneven squeegee blade will soon start producing variant streaks of uneven colour on the printed surface.

When using these inks it is especially important to pay particular attention to how the stencil is charged with ink: with a thick layer the printed colour will be stronger than with a thin layer. The printed colour will also be stronger when the stencil is charged twice; this may be desirable if the printed colour is found to be marginally too weak during proofing. The important point is that the charging or flooding must be equal for each print, in order to maintain consistent colour throughout an edition.

Blending or melding

Blending, the simultaneous printing of two or more merging colours, is common to all fine-art printing processes, screen printing being no exception. As with the other printing processes, blending is achieved in screen printing at the 'inking-up' stage. Assuming that the screen is attached to the hingeing mechanism at the rear of the press then the printing direction has to be in sympathy with gravity – that is, from the back forwards. The stencil should be placed on the screen accordingly.

When the colour range of the blend has been decided, the mixed inks are poured along the front inside edge of the screen, each making up one section of the ink reserve in proportion to how the printed blend is envisaged. The stencil is then charged with ink as in normal printing, and the ink reserve agitated with the squeegee to make the colours mix at their meeting points. The first proof is pulled and it will be observed that the edges of each ink section have begun to merge with their neighbours. After a few proofs a cleanly gradated blend will appear. The degree of merging can be adjusted by angling the squeegee during stencil flooding.

Printing two or more colours at once

If there is a way to save time while printing without sacrificing quality, by all means take advantage of it. Sometimes during a print edition it is possible to print two separate colours simultaneously, that is, when there are two well-separated stencil areas requiring two different colours. The two inks can be poured onto the screen and printed with two squeegees. Even when the two areas are relatively close together and there is some danger of the inks mixing they can be separated by an artificial wall made from a strip of card taped to the screen. The saving is that, although twice as much time is spent at the screen, the paper is only registered and racked once.

Partitioning the screen in order to print two colours at once.

Printing with the squeegee arm

Many factory-made presses now incorporate a squeegee arm mounted on a tubular metal bar running parallel to the screen along the hingeing mechanism and projecting above the screen at right angles to the mounting bar. It incorporates a clamping mechanism for holding the squeegee. The squeegee arm is free-moving on the mounting bar and the printing direction is invariably from side to side. On very large presses the printer can actually walk along the length of the press using the squeegee arm to print comparatively huge areas of colour under even pressure.

REGISTRATION

Registration is best defined as the point at which the printing stock is in greatest agreement with the stencil. As there are no absolutes there can clearly be no such condition as perfect registration. 'Perfect' registration can never be more than the most tolerable misregistration, and is totally dependent on the quality of the equipment. Obviously the accuracy of the registration is related to the complexity and tightness of the image. Here it will be assumed that the aim is to achieve the least registration discrepancy for the most complex and critical image; any print with less crucial requirements will be a comparatively simple task.

At every stage of screen and stencil preparation there are factors, minute or otherwise, that will affect registration. The sum total of such factors, if ignored, can amount to irretrievable registration error.

The most accurate registration is achieved with a screen which has been stretched to its maximum tension, with the use of stencils that relate accurately to one another, with consistent squeegee printing throughout the edition, and with the use of an efficient registration method.

Registration through the screen

The most commonly observed method of registration is 'through the screen'. The master drawing, the master print or the photographic positive (each mounted in correct position on a sheet of the printing stock) from which the stencils are derived is placed underneath the lowered screen and manoeuvred until it is seen, from above, to be in closest alignment with the screen stencil. This process can be aided by the use of a card extension which is taped to the master drawing and allowed to project out from underneath the screen, thus facilitating movement of the master drawing without frequently having to raise the screen.

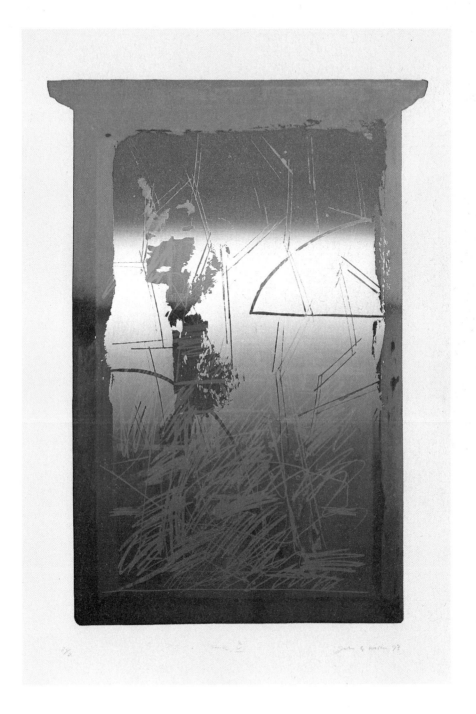

John Walker, *Tank V*, 1973, 104 × 75 cm. Published by the artist in an edition of 50. Screen printed from original source material (a church notice board) using photographic and hand-painted stencils. Note the multicolour blended ink. 15 printings plus 1 hand embossing. Printed by Advanced Graphics.

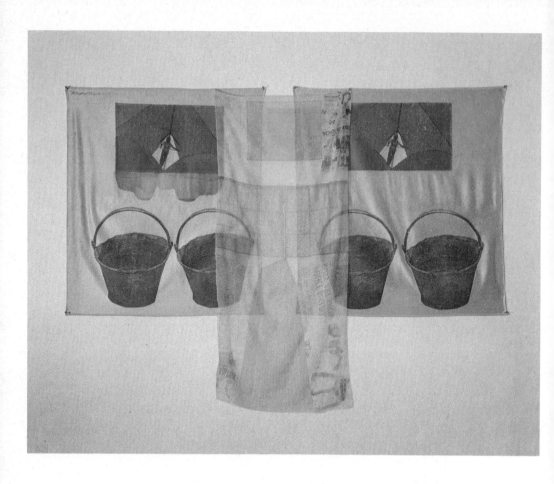

Robert Rauschenberg, *Plus Fours*, from *Hoarfrost Editions*, 1974, 170·2 × 241·3 cm. Published by Gemini G.E.L., in an edition of 28. This is a mixed media work using transferred printed images and collage. All the images were either offset printed or screen printed before being applied to the silk satin and the overhanging silk chiffon by means of a textile transfer process. The buckets, newspaper and building images were offset printed and the hang-glider image screen printed. Printed by Gemini G.E.L.

The fact that, at this stage, the stencil and the printing stock are in perfect agreement does not guarantee that they will be when the print is taken. The pressure of the squeegee pull across the screen will move the printing position of the image relative to the stencil and in proportion to the mesh tension. This should be taken into consideration and due compensation made when establishing registration on the press.

A paper extension used for registering the print through the mesh.

Registration using an acetate sheet

Another method of registration, and a highly efficient one, involves the use of a sheet of clear unrumpled acetate, which should be, either on its length or on its width (but not both), greater in size than the printing stock and large enough to accommodate a print taken from the complete stencil image. The acetate is taped flat down on to the surface of the printing press. It is taped along its comparatively shorter sides in order to allow the master drawing to be slipped under the acetate for easy adjustment into accurate registration. The print is then taken onto the acetate, the paper slipped underneath and registered, and the acetate removed to allow continued printing. The advantages of this method over the previous one are that the image printed on the acetate for registration is located in the exact printing position and is the exact printing size of the stencil. The disadvantages are that the delay, due to the fact that registration is located after beginning the printing, may allow ink to dry in the stencil and necessitate cleaning before the print run is undertaken, and that, in some print-room conditions, there may be a build-up of static causing the stencil partially to stick to the acetate. This can be prevented by wiping or spraying antistatic fluid onto the acetate.

Registration marks

Photographic screen processes make use of registration marks on each positive in the form of crosses that are either on the original artwork, or that are added to and

registered to each positive before making the stencils. They are placed outside the image area and are used as reference points when registering each stencil to the existing print. This method can be adapted for hand-drawn and hand-cut stencils by devising marks that can be drawn or cut in register on the stencils. The marks are printed on the registration proofs and when registration agreement is established between them they are obliterated with tape or screen filler and the print run is continued.

Registration location

No matter which method is chosen for establishing registration, the location of the printing stock is made in the same way. Three small rectangular pieces of thin but strong card, approximately 5×2 cm ($2 \times \frac{3}{4}$ in.) and each with one straight edge, are used to locate the paper.

The paper, having been registered, is temporarily fixed in position with two short pieces of tape. Two of the registration stops are then taped in position along the nearest edge of the paper – one by a corner and the other at a point two-thirds of the length of the paper away from it – so that they butt up to the edge of the printing stock leaving only a small fraction of the straight edge of the card projecting from under the tape. The third register stop is similarly placed to make a right angle with the existing corner stop.

Every sheet of paper is then fed into these registration stops during printing, thus ensuring that the image falls in the same relative position on each sheet of paper throughout the edition.

It is important that the corner and the sides of the paper used for registering the first stencil continue to be used for each stencil throughout the job, for, no matter how well guillotined a ream of paper is, there will always be misregistrations if registration location points are changed.

The second stencil can be registered either to the master or to one of the prints. If it is possible to print the first registered colour onto the master this will make subsequent registration easier.

Registration adjusters

Many vacuum presses have registration adjusters on three sides for moving the printing bed in any direction and to compensate for misregistration. Usually it is easier and more controllable to move the registration stops.

Screen printing by reduction

The simplest and theoretically most perfect of all registration tasks is in screen printing by reduction. The first

Register tabs in the position on the press where they produce the best registration of the paper (detail above).

Alternative type of registration tab.

stencil is usually an open area which provides the background colour, and each subsequent stencil is provided by masking out progressively more of this open area until the whole image has been built up. The screen and the registration stops are never moved and therefore registration problems are minimal.

CLEANING THE SCREEN

Cleaning the screen, either during printing or at the end of a colour, is the part of the process that is most likely to alienate people from screen printing because it is regarded as being impossibly messy, yet if it is performed properly it can be a relatively clean process. After a run of printing has been finished all the remaining ink should be collected on the screen surface and squeegeed to one end of the screen, leaving any ink in the stencil printed out on to a clean sheet of newsprint. Practically no ink will be left in the stencil itself: what does remain is then collected up into the ink container with either a piece of card or the palette knife. A solvent should not then be poured on the screen as this will only create greater clean-up problems; instead, a series of rags (solvent-soaked followed by dry) should be used. The final wipe on an indirect stencil that is to be retained can be made through the stencil on to a clean sheet of newsprint. In this way any excess ink is removed from the underside of the stencil without actually touching it with the rag and thus running the risk of stencil damage.

EDITIONING AND FINISHING PRINTS

Traditionally, fine-art prints are produced in limited editions and are signed by the artist (and occasionally by the printer also if one is employed by the artist) with a number which denotes the edition size and the number of each particular print. The artist's signature bears witness to the fact that the print is from a limited edition and is, as tradition would have it, therefore original. There is much dispute as to when a print is original and when it is not and also as to what constitutes a proper edition size. This results from the capabilities of photographic reproduction and production printing. It is usually held that an original print is a work of art that does not exist until the final printing has been applied. That is to say that it is not merely a reproduction (no matter how sophisticated) of an original master copy. A generous edition size is held to be in the region of 175 to 250.

The artist need not concern himself with this unless he wants to; whether a print is from a limited edition of 10 or an unlimited edition of over 10,000 does not change the

individual identity of the particular print or its artistic quality. It is up to the recipients of a print to satisfy themselves as to its pedigree if they cannot accept it on face value.

However, a signature and an edition number are a contractual statement and if they do accompany a print they must be used accurately and honestly. This will involve destroying or defacing original stencils or positives after the full edition has been printed, to ensure that no exact copies can be made.

It is also traditional for 10 per cent or so of the total number of prints to be signed as artist's proofs. Any variations and stage proofs should be marked as such to avoid confusion with the edition.

Monotypes and permutations

Screen printing is easily adaptable for quick and easy changing of colours and stencils, which enables the printer to make monotypes by permutation printing rather than producing an edition.

STORAGE AND PACKAGING

Freshly finished screen prints or printed stages of editions should be stored upright to avoid any paper adhesion from incompletely dried ink. Other than this, prints can be stored flat.

Prints should be posted flat if possible and, where rolling is necessary, they must be rolled loosely in a tubular container as wide as possible. (It is often advantageous to roll the print ink-side outwards, to avoid cracking the ink.) Rolled prints that are received through the post should be flattened under weights immediately.

12 Other uses of screen printing

The enormous flexibility and directness of the screen-printing process coupled with its relatively late development has allowed its potential to be exploited without preconceptions as to its limitations. This has led screen printing to take its place in all the traditional fields of printing, to prove itself in realms where non-printing procedures were formerly used, and even to create new areas of processing where possibilities did not exist previously.

Most print processes, barring intaglio, produce the printed image by imposing a surface impression onto the stock with an inked printing plate. The versatility of screen printing, however, lies in the fact that it is such a directly physical process. The ink is literally forced through the stencil onto the printing stock in order to produce the image. Once it has been realized that screen ink can be anything that will pass through the stencil successfully, and that the stock can be anything that will receive it, then the potential of the screen printing process becomes virtually limitless.

The developments that have stemmed from the use of screen printing in so many diverse industries are of direct benefit to the artist. They all conform to the one overriding quality of screen printing, which is that almost anything that can be achieved at the sophisticated industrial end of screen printing can also be successfully adapted for use by an inventive artist at the do-it-yourself level. It is beyond the scope of this book to plumb the intricacies associated with each of these tangential screen-printing processes. It can, however, give a description of the various processes in order to outline the possibilities and to encourage a deeper investigation by the artist.

SCREEN PRINTING IN TEXTILES

Screen printing in the textile industry is not only well within the mainstream of the process but it even has a history and development that precedes that of conventional paper screen printing. Screen printing is used so extensively for printing fabrics that whole areas of printing equipment and procedures have been developed that are now an essential part of the textile industry.

The basic procedure for screen printing in textiles was to gum whole lengths of fabric to very long tables and

then to move the screens progressively along the tables, thereby printing the whole fabric length in stages. Recent developments have led to the rotary screen which is a cylindrical drum screen and, as its name implies, rotates under the influence of an internal squeegee and a controlled well of ink. It dispenses with the need for long gumming tables.

The benefits from the textile industry to the conventional screen printer at the manual end of the process are that he can quite easily and economically devise a set-up for printing individual pieces or short lengths of fabric and so take advantage of the inks that have been specially developed for the textile industry. Evidence of this can be clearly seen in the abundant range of printed T-shirts that have become available in the last few years. (This in itself has led to the production of machines especially made for printing T-shirts!)

Most screen inks will print on fabric, and in fact ordinary screen inks are used for printing banners and pennants but owing to their pigmentation they leave a stiff surface deposit, and they are certainly not resistant to dry cleaning and washing. When 'handle' is required in a printed fabric, special inks made from pigment dyes can be used in conjunction with a polyvinyl acetate (PVA) bonding medium. A water-resistant direct stencil should be used in conjunction with these inks, and two or more squeegee pulls may be required. This ink will air-dry but it must be heat-cured in order to fasten the ink before the printed fabric can be washed; heat curing, in effect, thermosets the ink. If a special machine is not available a hot iron can be used. These dyes can also be used very effectively for printing on paper, when heat-curing is not necessary.

When printing articles of clothing, it is an advantage to insert a shaped board into the garment to improve the fabric surface for printing. If a number of garments are being printed the board can either be hinged into fixed register or registration blocks can be devised. A vacuum press is obviously not necessary.

Screen printing is also used in textiles for the application of the dye resist and discharge processes.* In the dye-resist process a resist is printed into the virgin fabric, which is subsequently dyed, leaving the resist areas unchanged. The discharge process is effectively the opposite of this and happens when a special combination of resist and bleach is printed into a ready-dyed fabric, enabling the original colour to be removed and replaced simultaneously.

Heat transfers

The production of heat transfers is a process that is easily adapted to the conventional screen printing set-up.

* See also Joyce Storey's *Manual of Textile Printing* in this series.

Special Plastisol-type inks are required (these inks are also used for direct fabric printing). The design is printed on a transfer release paper and then heat-cured for approximately 1½ minutes at 120°C. (250°F.). The transfer can be applied to the garment with a hot iron or with a heat-transfer machine set at 190°C (375°F.) for 15 seconds. When the transfer has cooled the paper may be peeled away.

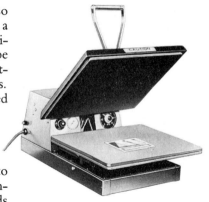

Marler textile transfer press (photograph courtesy of E. T. Marler Ltd).

Screen printing on canvas

Screen printing has frequently been used by artists to apply both autographic and photographic images to canvas. The approach to this printing problem depends wholly on the part the printed image is expected to play in the finished canvas. The canvas, in the raw state, can be treated as a fabric, whereas once it has been primed the ink must be chosen in relation to the new surface.

Most screen-printing textile inks will be appropriate for use on canvas, and after heat curing the canvas can be sized and painted over. Conventional oil-based inks will also take to raw canvas but not with such permanence. The degree of intricacy possible in the printed image depends largely on the fineness of the canvas weave.

Conventional oil-based inks can be used when the canvas has been primed with emulsion. If the canvas has been primed with acrylic paint, then vinyl inks will be suitable. It is important to make compatibility tests between the inks and the surface as some liaisons will cause the ink to flake away.

It is more convenient to print the canvas unstretched, but, if it is on a stretcher, a board can be inserted into the frame to give solidity to the canvas surface during printing.

FLOCKING

Flocking is a process allied to screen printing which is used for giving a kind of artificial velvet feel to paper. The flock itself is a synthetic fibre which is supplied in various lengths and numerous colours.

The desired image is printed on the paper with gloss ink, varnish or special adhesive. The paper is laid against a vertical metal sheet and the flocking fibres are fired at it with a distributor gun. This sets up a static electrical charge between the metal and fibre and causes the fibre to stand on end in closely packed formation when it hits the adhesive. The colour of the ink adhesive will influence the colour effect of the flock. All excess flocking fibres should be vacuumed off the print. Flocking can be performed on fabric and other materials but tests should be made with adhesives before assuming any permanence.

Flocking machine being used.

The flocked surface can be overprinted with other colours.

Flocking should be performed in controlled, ventilated conditions and operators should wear protective masks as inhaled flocking fibre is detrimental to health.

DUSTING SCREEN PRINTS

Many surface effects can be achieved by screening varnish onto the printing stock and then dusting it with metallic powders, sand, glitter or any number of granulated substances. A thick varnish deposit is an advantage in this process, and an even thicker deposit will be achieved by using a squeegee with a rounded blade.

PLASTICS

A large industry has developed out of the ability of the screen process to print on plastics. Special gloss and matt inks have been manufactured for printing on all plastic surfaces and many of these are formulated to include additives which enable the ink to function also in post-print processes such as vacuum forming and blow moulding.

The problem of making printing ink adhere to a plastic surface has been largely overcome by including powerful solvents in the ink. These solvents, usually higher ketones, are also solvents of the plastic and so effectively cause the ink to weld itself into the plastic. The inks can, however, cause thin PVC sheeting to crinkle and surface crazing to occur on some plastics. The most modern inks have overcome surface adhesion problems without the inclusion of such powerful solvents.

Before printing it is advisable to wipe the surface of the plastic sheeting with a rag soaked in white spirit, to remove any unwanted surface film. (One advantage of printing on plastic is that substandard printing can be easily removed to allow the plastic to be reprinted.) Ink must be removed with screen wash or white spirit but not with the ink solvent, which is liable to attack the plastic surface.

Before buying printing ink, always tell the manufacturers the nature of the plastic and its designated purpose. It should be noted that there is a wide range of solvents used with plastic inks, so great care must be taken to ensure that the appropriate solvent is always used.

PRINTING FOR VACUUM FORMING AND BLOW MOULDING

Thermoplastic sheeting is used in both the vacuum-forming and blow-moulding processes. 'Thermoplastic'

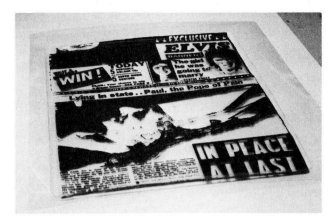

Screen printing used in the vacuum-forming process.

is a term that describes the ability of certain types of plastic sheeting to soften for reshaping under the influence of heat. The plastic may be coloured, transparent, or opaque. It can be PVC, acrylic or polystyrene sheeting – but whichever it is it must be printed with thermoplastic inks which will become part of the sheeting and which will mould with it to the required shape during the forming process.

There is practically no operational difference between printing on plastic sheeting and printing on paper. Static electricity can be a problem with plastics, but antistatic liquids and aerosols are available for dealing with this. Many plastic inks are self-solvent on the screen and are also suitable for printing on paper.

POLYTHENE CONTAINERS AND SHAPED OBJECTS

Special machinery and inks have been developed for printing plastic containers, and will print cylindrical, oval, and conical containers.

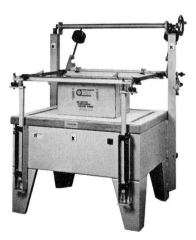

Plastic containers are largely made from polythene, which has the advantage of being inert and therefore ideal for carrying a wide range of chemical products. As polythene in the untreated state gives very little adhesion to ink, the containers are flame-treated before entering the printing machine, which is designed to print by rotating the container while moving the screen back and forth in the horizontal plane. The inks are not only formulated to adhere to the treated polythene but they must also be resistant to the contained product. They are normally flame- or stove-dried.

KPX screen-printing machine for use with three-dimensional objects (photograph courtesy of Pronk, Davis & Rusby Ltd).

Care must be exercised in the choice of stencil material when printing plastic-formulated inks as solvent-adhered stencils will be eroded by the powerful plastic ink solvents.

METALLIC SURFACES

The vitreous enamel process traditionally used for the production of metal signs is now losing ground to the screen process, which can be used to produce signs more simply and economically.

It is extremely important to clean and prime the metal fully before printing, as different metals require different preparation methods. The inks used for printing on metal, known as 'stoving' inks, are baked, or 'stoved', after printing in order to establish their permanence. If desired, the baked inks may be overprinted and re-stoved. Stoved inks are extremely durable and light-fast.

Enamel inks can also be printed on fully prepared metal surfaces but they need vitrification in a special enamelling furnace and are therefore not quite so adaptable to the conventional screen-printing set-up.

CERAMICS

Ceramic inks have been specially developed for both screen printing directly on ceramic tiles and for application to ceramic objects through the transfer process. For the best effect, it is normal to use a coarse screen to deposit a relatively thick layer of ink. After direct printing the tile is re-fired in order to fuse the ink to the ceramic surface.

If a printed design is required for a shaped ceramic object, or even if a tile design is to go right round the bevelled edge, the transfer process is used. The design is printed on a gelatinized, starch-coated transfer paper; when the ink is dry the transfer paper is soaked and the backing sheet slides away. The ink-bearing film is then applied to the ceramic piece and the whole is fired. The film burns away during firing, leaving the ink glazed and bonded to the ceramic object. All the usual stencil materials are suitable for this.

GLASS

Screen printing on glass is very similar to ceramic screen printing, and the same type of ink is used. It also requires firing for permanence and bonding. Again, the inks can be applied directly or by the transfer process.

There is a second type of ink used in glass printing which is air-drying and is manufactured with the inclusion of hard resins. There are also two-component inks based on epoxy resins which are catalysed and which dry to a tough quality.

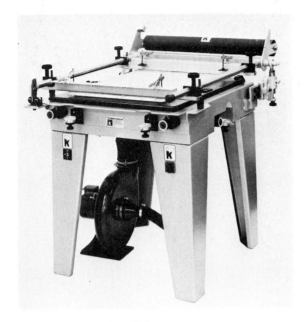

KPX hand-operated circuit printing machine, de luxe version (photograph courtesy of Pronk, Davis & Rusby Ltd).

PRINTED CIRCUITS

Electronic circuits are produced by the screen-printing process in two different ways – either with electro-conducting inks or with acid resists.

The commonest procedure is to print the circuit design, with an acid resist, on a thin sheet of copper laminated to a non-conducting support. The copper laminate is then placed in a bath of ferric chloride and etched through to the support. (The resist ensures that the circuit is fully protected and therefore accurately retained.) Once the resist has been removed the circuit can be wired up for its designed function.

The process of actually printing electrical functions on supports such as ceramic tiles with electrically conducting inks is far less common; it has to be highly accurate and must be performed under controlled conditions.

ETCHING AND LITHOGRAPHY

The acid-resist process described above for making printed circuit boards is equally appropriate for applying images to metal in the fine-art process of etching. Autographic or photographic images can be screen-printed onto a thoroughly degreased etching plate with the acid-resist ink, and the plate is etched to produce the printing plate. Ordinary etching stop-out varnish can be adapted for this purpose. Liquid tusche can also be used, and even ordinary screen ink will resist acid to some extent. Aquatints can be laid on the plate after the resist image has been printed but before it has been etched.

Screen printing used as an acid resist on copper plate for etching.

It should be remembered that a stencil made from a negative rather than a positive will be required to produce a positive intaglio printing plate. A positive stencil will produce a plate that will only print positive through surface inking. This, therefore, is a method of producing letterpress plates. The eventual plate-printing image will naturally be the reverse of the screen-printing stencil.

In much the same way as has been described for etching, autographic and photographic images can also be screen-printed on a prepared litho stone or plate. The images can then be printed as part of the lithographic process. (Inking-in solution or liquid tusche are the best

Screen printing onto a lithographic stone.

inks to use.) A positive stencil will produce a positive but reversed litho printing image. This approach presents widespread possibilities for the artist, particularly with regard to achieving photographic images on a litho stone without too many problems. The usual screen stencil materials are suitable.

In addition to printing resists for use with etching and lithography, screen printing can be exploited to print acid resists in other etching-type processes.

Resist can be applied to linoleum in order to etch photographic or autographic images with a caustic soda solution. Both plastic and glass can be etched under the influence of screen-printed resists, which, after acid processing, can be removed with their respective solvents.

Great care must always be taken in any of these etching processes to avoid all the dangers associated with acid processing.

Images or designs can be screen-printed on glass with the toughest screen inks, which will create a barrier to stand up to the sand-blasting process.

THE FOOD INDUSTRY

Perhaps one of the most remarkable ways of showing the versatility of the screen process is in describing how foodstuffs are occasionally printed in the food industry.

Egg white was one of the earliest materials used as a binder for pigments (in tempera painting, for instance). It is possible to combine egg whites with food colouring or vegetable dyes to produce an ink that can be printed on any other suitable foodstuff – for example, pastry, rice paper, rolled marzipan, or icing. This, of course, must be performed under the strictest hygienic conditions with full knowledge of what you are doing, since the produce is intended for consumption.

In addition to the printing functions that have been specifically mentioned there are numerous other screen-printed materials in various fields of industry and commerce. Such materials as wood, leather and cork are all screen-printed as a part of one industry or another; carpets and furs are screen-printed; billboard posters, with their huge colour-separated dots, are screen-printed. Graphic designers use screen printing to produce 'one-off' jobs and 'finished' visuals for assessing big printing jobs. There are photo-sensitive inks, embossing inks, and there is an ink that expands after printing. Even etchants can be printed. Various gums are available for printing on the back of display materials in order to make them adhesive. In fact the scope is so wide that it is true to say that anything that can be forced through the screen stencil must be printable onto something else.

155

When using any special inks it is important to remember that the solvents, stencils, meshes, squeegees and printing stock must be fully compatible if you are to avoid operational problems. Manufacturers must always be consulted and their instructions scrupulously followed.

THE SQUEEGEELESS PRINTING MACHINE

This is a recent development in the screen-process industry. It consists of a printing bed and screen, working on a vacuum principle and using jelly-type ink. The inks are placed on the screen above the stencil areas that they are intended to print through; being jelly, they rest there without seeping through. All open stencil areas must be completely blocked by ink. Several colours can be placed on the screen at the same time, since the inks are so constituted as not to mix on contact with one another.

The screen is brought into contact with the bed, a seal is formed and a vacuum pump sucks the ink-charged screen stencil into contact with the printing stock. Current results are impressive, although the printed ink quality tends to be stippled. The great advantage is that several colours can be printed at the same time which considerably reduces the time and stencils needed for producing finished work. It is said that the inks will remain solvent on the screen for long periods of time. This machine is, however, in its infancy at the moment: no doubt future developments will improve its quality.

13 Workshop practice, health and safety

Good housekeeping is essential if a studio is to be efficiently and safely run. All working surfaces, furniture and equipment should be kept clean in order to avoid contamination of either persons or materials. There are many clichés, which nevertheless convey sound practical advice and information, in the field of workshop practice. Some of them are: 'a clean room makes a clean print', 'leave as you would find', 'a place for everything and everything in its place'.

Bins should be provided at strategic points for all waste, and should be fire-proof as most screen printing waste is inflammable. Special care should be taken to eliminate any sharp corners on furniture or equipment in areas used for the passage of stretched screens. It does not take much to rip a stretched screen.

Chemicals and solvents must be stored below head height in order to avoid any damage to the eyes from a loosely capped container. Glass containers must not be used for solvents, and any chipped or cracked glass containers that are in use must be thrown away as they are liable to break when containing dangerous substances. Containers should also be kept clean in order to prevent contamination spreading to the hands and the work. Any spillages or breakages must be dealt with promptly; the longer they are left the greater the hazard they present.

Electric wires must not be allowed to trail across the floor as they will not only trip people up but also gradually wear out, creating the risk of fire and electrocution.

In addition to good housekeeping, habitual personal hygiene will also help in the production of clean work and will provide safeguards against chemical contamination. Frequent washing of hands is recommended especially after any contact with the process substance.

It is extremely important to be acquainted with exactly what is being dealt with chemically. The properties of chemicals, solvents etc. should be known. It is wrong to take any substance for granted for although it may only represent a small or seemingly negligible risk in itself a range of substances can build up what is known as the 'total body burden' – that is, the cumulative effect of frequent but small exposure to toxic substances on a person over a period of time.

If solvents or chemicals are in use with non-conventional screen-printing processes – for example,

plastics and ceramics – then all relevant information about the use and the safety, not only of the solvents and inks, but of the printing stock itself must be obtained from the manufacturers. All these materials and substances should be clearly labelled to avoid wastage and misuse.

If there is a choice of chemicals and solvents, always opt for the least toxic and inflammable even if it lengthens the process slightly or is more expensive. Good ventilation, as has been frequently mentioned, is essential in a screen-printing studio.

Information about the use and the safety aspects of materials used in screen printing should be posted around the workshop in the appropriate places. In a studio used by numerous people procedural rules will have to be established and followed in order to ensure efficient processing, and personal safety from the misdeeds of other individuals. Further notices (available from official accident-prevention bodies) demonstrating emergency aid for any type of likely accident should also be displayed and read.

A first-aid kit which is fully stocked to provide for any likely accident should be kept in a readily available position and reserved purely for medical use. It should contain an eye bath, eyewash, acid neutralizer, burn lotion, antiseptic bandaging, lint, gauze, disinfectant, vinegar, plasters, a pair of scissors, milk of magnesia, cotton wool, cotton buds, a sling and a first-aid book.

Apart from fire there are numerous potential hazards in the screen-printing process but the extent of damage depends of course on the degree of contact or exposure and on the toxicity of the substances in question. If all precautions are taken and all contingencies are catered for, which they should be, the process will be a relatively safe one, and the safer the environment is, the more efficient the studio is likely to be.

HEALTH HAZARDS

There is a considerable degree of ignorance among both artists and printers of the widespread hazards involved in the screen-printing process. This is the one area of the process where corner-cutting can never be justified. The chemicals and materials used in screen printing can to a greater or lesser degree harm the unprepared operator in any of a number of different ways.

The chief areas of personal vulnerability to toxic substances are from direct bodily contact, absorption through the skin, inhalation and digestion. In addition to these there is the very real danger of fire. Provided that precautions are properly taken these hazards can be minimized.

Ivor Abrahams, *Open Gate,* 1972, image size 83·2 × 149·5 cm. Published by Bernard Jacobson, in an edition of 100. Screen printed from enlarged magazine source material using photographic and hand-painted stencils. A total of 57 processes were used, including multi-layered flocking (the plants to either side of the gate) and forme-cut collaged elements (the gate and the wall). Printed by Advanced Graphics.

Joe Tilson, *Transparency, the Five Senses, Taste*, 1969, 147 × 147 × 5 cm. Published by the Marlborough Gallery, in an edition of 3. The main image was screen printed as a four-colour separation on the back of clear acetate sheeting and an extra black was printed for the surround. A white was also printed in order to seal the image. The acetate print was then inserted into the vacuum-formed slide carrier. 6 printings, printed by Kelpra Studio Ltd.

Skin contact

Skin contact with chemicals can lead to a number of skin ailments. Dermatitis, which is an allergic reaction, is the commonest of these. Many people are especially prone to dermatitis and will manifest the symptoms of the disease after a relatively small amount of chemical contact; others will only contract it after a considerable period of contact with strong chemicals. The substances that most frequently cause dermatitis are known as 'sensitizers', and among these bichromates and turpentine are the ones that are most often responsible for the condition. The symptoms of dermatitis are skin reddening followed by itching, blistering and then the skin flaking away. This can occasionally occur on other parts of the body as well as the hands and arms. Dermatitis is, in effect, a breaking down of the protective skin layer and can lead to further problems from the absorption of chemicals through the skin. The dermatitis will clear up if no further contact is made with the chemical in question but once the allergy has been established even the slightest further contact will renew the disease. Approximately one person in ten is prone to contracting dermatitis but it is advisable for everyone to take precautions if only to avoid slight skin irritations. The obvious precaution is to wear rubber gloves when handling chemicals as it is the hands that will be most frequently in contact with the chemicals. Care must also be taken to ensure that the chemicals do not enter the gloves, as the gloves would then represent a hazard in their own right. Hands must be kept clean and they should be softened with cream if they become dry. Great care should be taken to protect cuts and grazes from chemicals. Barrier creams are also useful in avoiding chemical contact, but not to the same extent as gloves.

There are occasions when the eyes must also be protected during screen printing. As already mentioned, there are dangers to the eyes from ultra-violet light during stencil exposure. This is avoided by either not being present during the exposure or by wearing protective goggles to absorb the ultra-violet. The eyes are also in danger from chemical splashes, so it is advisable to wear protective goggles when pouring chemicals that may splash back. If a chemical does splash into the eye it is important to wash it immediately and thoroughly with water. An eye bath should be kept in the workshop for this purpose.

Absorption through the skin

In addition to the dangers from contact with chemicals there is an added danger in that some solvents and chemicals are capable of penetrating the skin and working their way further into the body system. Gloves should therefore be worn for protection against chemicals.

Inhalation of fumes and dust

Some of the solvents used in screen printing give off particularly heavy vapours and, as already mentioned, a carbon-arc lamp emits harmful gases during stencil exposure. As continuous inhalation of these fumes and gases is detrimental to the lungs and to the blood system, precautions must be taken. Good ventilation and air extraction are absolutely essential when using solvents. It must be remembered that, although only small dilute quantities of strong solvents may be in use, they can have a cumulative effect allowing the real damage to build up over periods running into years.

Dust is present when sanding or grinding screen frames or even when using fine silicon carbide to prime new mesh. A mask should be worn over the mouth during sanding procedures.

Toxic substances in the digestive system

Swallowing chemicals would not seem to be a normal hazard in the screen-printing process but it is, nevertheless, possible, usually through the contamination of food. Food must not be eaten in the studio as it carries chemicals into the digestive system; for that matter, contaminated hands must not be put near the mouth or eyes. If it should happen that chemicals are swallowed, medical help must be obtained immediately. Meanwhile, action must be taken, consisting of drinking lots of water and, in the case of acids, water and milk of magnesia.

The hazards in screen printing are directly proportional to the amount of time spent in the studio, the type of chemicals in use and the safety precautions that have been taken.

A list of chemicals encountered in screen printing is given here, together with their properties and recommendations for handling. The appropriate emergency steps are given for dealing with accidents but medical help must always be sought as soon as possible.

All *screen-mounting adhesives* set with a certain degree of vaporization. This implies the need for ventilation. Two-component adhesives incorporate epoxy resins which are sensitizers to dermatitis, so protective gloves must be used when handling them.

Caustic soda itself is used in some cases as a screen degreaser and in other cases it is present as a constituent part of manufactured degreasers. Caustic soda should always be added to water, not the other way round, as otherwise heat can be generated, and explosive splashes can cause danger to the eyes and skin. If it does go into the eyes, they must be thoroughly washed and medical help sought. If it is swallowed the mouth should be washed

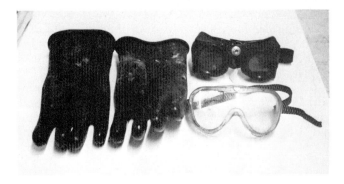

Protective gloves and goggles for protection against UV light (upper pair) and chemical splashes (lower pair).

and plenty of water followed by vinegar must be drunk. Caustic soda is corrosive, so rubber or neoprene gloves must be worn while handling it.

Carbon tetrachloride is a strong degreasing agent. It is occasionally used as a screen degreaser or as a constituent part of a screen cleaner or solvent. It is however narcotic and highly toxic, leading to nausea, dizziness and even coma. It is also responsible for causing damage to the liver, kidney, nerves and even the heart. It should be avoided at any cost as there is always an alternative and safer chemical.

If by any chance it is used and the fumes are inhaled the victim must be rested and medical help sought. If the eyes or skin are in contact with carbon tetrachloride they should be thoroughly washed with water and soap; if swallowed the mouth must be washed out and in both cases medical help must be obtained. Carbon tetrachloride must only ever be used in a specially controlled environment by a trained and knowledgeable operator. Good ventilation, face masks and gloves must be used if this substance is ever applied.

The *bichromates* used as sensitizers in direct photo stencils can easily cause dermatitis and ulceration of the skin. Under no circumstances must they be allowed to make contact with cuts, so protective gloves must be worn. The de-coating agents must be treated with similar respect.

Hydrogen peroxide is used for developing many indirect photo stencils. In a concentrated form it is a skin and eye irritant, and it is also harmful if swallowed. In the event of contact, eyes and skin must be thoroughly washed, and if it is swallowed plentiful water should be taken.

Bleach is used for removing some photo stencils. In the event of eye or skin contact, wash with water. Should the bleach be swallowed, then plenty of water must be drunk.

Inhaling *flocking fibre*, or any dust for that matter, is to a greater or lesser degree (depending on quantity and type) hazardous to health. Masks must be worn while handling dust materials.

The *solvents* used in screen printing must be treated with considerable respect because of not only their toxicity bu also their inflammability. In addition, solvents have a narcotic effect, often causing dizziness and headaches.

The main solvents used are white spirit and screen-wash. White spirit is a turpentine substitute and is not very toxic although continuous contact will cause skin irritation or even dermatitis in some people. Screen-wash, however, should be treated as a dangerous solvent. It is made from aromatic hydrocarbon chemicals such as toluene (toluol) and xylene (xylol) which are both highly inflammable and toxic. The vapours from screen-wash can cause not only dizziness, fatigue and nausea but also liver, kidney and blood damage through skin absorption. Screen-wash is also a skin irritant. It must be used in well ventilated conditions and gloves must always be worn. If solvents such as these are swallowed, medical help should be obtained immediately.

Benzene (benzol) is a highly toxic and inflammable solvent and is in fact outlawed in the UK. If there is any benzene in the studio it must not be used but given to the authorities for disposal. Accidental contact with eyes, mouth or skin is treated by washing in water. If it is swallowed, medical help must be sought immediately.

The solvents used with special inks vary according to the constitution of the ink. Most are toxic and practically all are inflammable. They should be treated with the same caution as screen-wash unless the manufacturers direct otherwise. Drying retarders and extenders must also be treated with similar caution.

Aerosol products represent a particular problem in that they can diffuse toxic and inflammable substances over wider areas. They also carry a greater volume of the toxic chemical than vapour does and are capable of deeper penetration into the lungs. Screen-printing aerosol products are generally strong ink solvents and are used to prevent ink from drying into the stencil during printing. These are constituted similarly to screen-wash and are therefore obviously quite hazardous in aerosol form. The precautions of good ventilation and even face masks should be taken.

Inks

The composition of inks is traditionally privileged information and so it is rather difficult to determine the toxicity of screen ink. Many oil paints are made from toxic pigments, some of which are also used in oil-based screen inks. The main danger is from ingestion which is, as already stated, not a normal hazard provided good hygiene is adopted. Many inks are inflammable and should be stored in fire-proof containers. They can also

cause skin irritation to allergic people who should there-fore wear rubber gloves. Special inks, including varnish, are liable to be much more toxic in terms of contact and vaporization, so all due caution should be taken, such as good ventilation and rubber gloves.

Toxic chemicals in the general darkroom

It is likely that a screen workshop will incorporate a general darkroom. This darkroom will contain several chemicals requiring careful handling. The developer can cause skin irritation, allergic reactions and even burns. Gloves should be worn and the hands should be thoroughly washed if contact does take place.

The stop bath is a very dilute solution of acetic acid. This solution must be prepared carefully as the concen-trated acetic acid can cause burns and also irritation to the throat and respiratory system through inhalation. The acid should be poured into the water (*not* water into acid) and goggles and gloves should be worn to avoid skin or eye contact. Should contact take place the eyes or skin must be washed with water. If acetic acid is swallowed large quantities of water should be swallowed.

Stop hardeners contain chromium and can ulcerate cuts. Protective gloves must therefore be worn. The fixer gives off sulphur dioxide, which is corrosive to the lungs and can also promote dermatitis. Intensifiers are danger-ous to the lungs through inhalation and to the hands through contact.

All the darkroom chemicals must be properly handled. Protective rubber gloves ought to be worn when hand-ling them and good ventilation is essential. Added to this goggles should be worn when pouring any of the chemi-cals. Any chemical contact with skin or eyes should be thoroughly washed. If swallowed plentiful water should be drunk and medical help sought.

FIRE HAZARDS

Many of the chemicals and materials used in the screen-printing process are inflammable and stringent precau-tions must be taken to avoid fire.

Solvents represent the greatest hazard in that they are highly inflammable. There is not only a danger of fire from actual contact of a solvent with a flame but all flammable liquids have a flash point – the lowest tem-perature at which a liquid will emit enough vapour to support combustion when an ignition source is in the close vicinity of its surface. The flash point is expressed as a temperature reading and the lower the flash point the greater the danger. Screen-wash, for instance, has a flash point between 5° and 20° C. (40°–68° F.).

Safety can for solvents.

Only working quantities of solvent (5 litres) should be kept in the studio. When not in use, solvents must be kept in fire-proof metal containers. Large stock supplies should be stored outside in a solvent shed and in fire-proof containers. If the studio does not have a separate outdoor store the volatile solvents must only be purchased in working quantities. The solvents that are in direct use are best kept to small quantities in approved safety cans. Glass containers should be avoided. Solvents must never be left near heaters or direct sunlight. Good ventilation is essential, to avoid the build-up of volatile vapours. Any aerosol products should be kept well away from heat in case of explosions.

Rags and paper must be stored safely. Used rags should be kept in fire-proof metal containers before disposal and large accumulations should not be allowed. Inks should be stored in fire-proof cupboards. Smoking must be strictly banned in the entire stencil department and print workshop.

Buckets of sand and fire extinguishers should be available at several easily accessible parts of the studio – both water type (for fighting wood, paper and rag fires) and carbon-dioxide extinguishers (for fighting fires involving thinners, solvents, or ink, and motor and electrical fires), must be provided. Water extinguishers must never be used to put out a solvent fire. Best of all, get the advice of a fire-prevention officer.

Two exits should be available out of every room. Fire exits must be clearly marked and all passageways kept completely clear. All users of the department must be educated in the dangers of fire and the location of fire-fighting appliances and fire exits. They should be fully drilled in the emergency escape procedures for the studio.

Further Reading

Autotype Stencil Techniques, Autotype Co. Ltd, Brown-low Road, London W13, 1978.

ELLIOT, Brian: *Silk Screen Printing*. Oxford University Press, 1971.

GILMOUR, Pat: *The Mechanized Image*. Arts Council of Great Britain, London, 1978.

Kissel and Wolf technical information sheets, Kissel and Wolf GmbH, D-6908, Wiesloch BRD.

KOSLOFF, Albert: *Photographic Screen Printing*. Signs of the Times Publishing Co., Cincinnati, Ohio, rev. ed. 1977.

Paper – Art and Technology, World Print Council, San Francisco, 1979.

Papermaking by Hand, J. B. Green, Hayle Mill, Maidstone, Kent, 1967.

SCHEER, Hans G.: *Graphic Screen Printing*. Zurich Silk Bolting Cloth MFG Co. Ltd, Rüschlikon, Switzerland, 1968.

Screen Printing. Swiss Silk Bolting Cloth Mfg Co. Ltd, Thal (St Gall), Switzerland, n.d.

TURNER, Silvie: *Printmakers Council Handbook of Printing Supplies*. Printmakers Council, London, 1977.

Glossary

ARTWORK
: The drawing, collage or photograph from which the photographic positive is made.

BASEBOARD
: See Printing bed.

BICHROMATE (AMMONIUM OR POTASSIUM)
: A chemical substance used in the manufacture of photo-sensitive screen emulsions. Currently the subject of some controversy as bichromates are not biodegradable. Diazos are now favoured.

BLEEDING
: Excess ink straying to the underside of the stencil and causing spread of the image during printing; usually due to runny ink or a thin stencil.

CHARGING OR FLOODING
: Using the squeegee to fill the open areas of the stencil with ink immediately before taking the actual print.

COLLOID
: The unsensitized compound (PVC or gelatin) used in the manufacture of photo-sensitive emulsion.

COPY
: See Artwork.

DEGREASER
: The chemical used to free the screen of all greasy substances and render it suitable for stencil adhesion.

DIAZO
: A biodegradable photo-sensitive chemical used in photo emulsions in preference to the non-biodegradable bichromates.

DRYING IN
: This is manifested by loss of detail in the stencil and occurs when the ink is allowed to dry partially on the screen – usually because of slow printing or thick ink.

INKING SIDE
: The side of the screen that is uppermost during printing and to which the printing ink is applied.

LIFT OFF
: See Snap.

LIGHT-FAST
: Describes inks that fully retain their colour when exposed to light.

MASTER
: The drawing, collage or photographic positive from which the stencils are produced.

MESH BRIDGING
: The way in which the photo stencil spans the screen mesh. The less the emulsion follows the undulations of the mesh, the better the stencil.

MESH
: Any fabric that is stretched on the screen frame to make the finished screen.

MESH COUNT
: The number and quality of threads per linear inch or centimetre in a mesh fabric.

The degree of stretch that is regarded as optimum when applying a mesh to the screen frame. MESH EXTENSION

See Snap. OFF CONTACT

The transparent photographic plate that is used to make the photographic screen-printing stencil. It consists of a photo-sensitive emulsion coated onto a transparent plastic base, usually polyester. POSITIVE/DIAPOSITIVE

The paper-receiving surface of the screen-printing press. PRINTING BED

The underside of the screen which is in contact with the stock during printing. PRINTING SIDE

See Printing bed. PRINTING TABLE

The additive (diazo or bichromate) which converts the colloid to a photo-sensitive emulsion. SENSITIZER (COLLOID)

A general term used to describe chemical substances that are liable to cause dermatitis in sensitive people. SENSITIZER (SKIN)

The action of taking the print. SQUEEGEE PULL

The gap that is left between the screen and the printing bed in order to allow the screen mesh to be progressively released from the paper as the print is taken. SNAP

The substance upon which the print is made, e.g. paper or sheet plastic. STOCK

An oil-based solution which will repel water-based filler and which is used in screen printing for the production of directly drawn hand-made stencils. TUSCHE

The thread direction in the mesh weave. The warp is the original thread setting on the loom and the weft the cross thread. WARP AND WEFT

List of Suppliers

UK

Argomatic Printing Machinery Ltd/George Hall Ltd, Hardman Street, Chestergate, Stockport, Cheshire: printing presses, mesh stretching equipment, troughs, photo-stencil films.

Autotype Co. Ltd, Brownlow Road, London W13: stencil films.

Cranco Engineering Ltd, Chapel Street, Long Eaton, Nottingham NG10 1EQ: printing presses, metal frames, stretching equipment and good range of sundry equipment.

Dane and Co. Ltd, 1/2 Sugar House Lane, London E15 2QN: printing inks, squeegees and material sundries.

Flock Coatings Ltd, Denham Way, Maple Cross, Rickmansworth, Herts: flock and flocking equipment.

Graphic and Display Products Ltd, Frogmore Road, Hemel Hempstead, Herts HP3 9RT (and in the North, the West and the Midlands): practically all graphic materials, including inks, stencil films, racks, mesh, plastic films, screen-printing machinery and equipment.

J. T. Keep, 15 Theobalds Road, London WC1X 8SN: screen inks and all related sundries.

E. T. Marler Ltd, Deer Park Road, London SW19 3UE: mesh, inks, squeegees, stretching equipment, degreasers, excellent printing presses etc., providing a full service for conventional screen printing.

A. J. Polak, 439/443 North Circular Road, London NW10: stretching equipment, inks and mesh.

Pronk, Davis and Rusby Ltd, 90/96 Brewery Road, London N7 9PD: comprehensive range of supplies for screen printing, including inks, meshes. squeegee rubber, light sources, printing presses, print-down frames. Agents for Colorgraph McGraw stencil films, Kissel and Wolf screen-printing sundries, Zurich Bolting Cloth Co. screen meshes and H. G. Kippax printing equipment. Mesh stretching service also available.

W. J. Reynolds, 99–105 Leytonstone Road, Stratford, London E15: Hydroblitz high-pressure water unit.

Samco Strong Ltd, PO Box 88, Clay Hill, Bristol BS99 7ER: manufacturers of the very solid, serviceable Golia printing presses.

Sericol, 24 Parson's Green Lane, London SW6: full range of supplies for screen printing, inks, meshes, stencils etc.

Serigraphics, Fairfield Avenue, Maesteg, Glamorgan, Wales: screen-printing equipment and materials.

PHOTOGRAPHIC SUPPLIERS:

Agfa Gevaert Ltd, Brent House, 950 Great West Road, Brentford, Middlesex: Repromaster and all process materials.

Dainippon Screen (UK) Ltd, 84/88 Pinner Road, Harrow, Middlesex, HA1 4LQ: complete range of halftone screens, including a wide variety of patterns.

De Vere Ltd, 149 Fleet Street, London EC4: camera enlargers.

Grant Equipment and Supplies, Grant House, Kingston House Estate, Portsmouth Road, Thames Ditton, Surrey: Grant enlargers and related equipment.

Ilford Ltd, Berners Street, London WC1: full range of process photographic supplies.

Kodak Products Distribution, PO Box 33, Swallowdale Road, Hemel Hempstead, Herts: full range of process photographic supplies.

Littlejohn Graphic Systems, 16/24 Brewery Road, London N7 9NB: process photographic equipment.

Process Supplies, 13–19 Mount Pleasant, London WC1X OAA: full range of process photographic materials.

ARTISTS' PAPERS, INCLUDING HAND- AND MOULD-MADE:

Atlantis Paper Co., F3 Warehouse, New Crane Wharf, Garnet Street, Wapping, London E1.

R. K. Burt, 37 Union Street, London SE1.

Falkiner Fine Papers, 4 Mart Street, London WC2E 8DE.

T. N. Lawrence, 2 Bleeding Heart Yard, Greville Street, London EC1.

USA

Advance Process Supplies, 400 North Noble Street, Chicago, Illinois 60622.

Chicago Silk Screens Supply, 882 North Milwaukee Avenue, Chicago, Illinois 60648.

McGraw Colorgraph, 175 West Verdugo Avenue, Burbank, California 91502.

PM Color Inc., 3401 Division Street, Chicago, Illinois 60651: suppliers of the squeegeeless printing machine.

Process Supply Company, 986 Hanley Industrial Court, St Louis, Missouri 63144.

Silk Screen Supplies Inc., 33 Lafayette Avenue, Brooklyn, New York, NY 11217.

Ulano, 210 East 86th Street, New York, NY 10028: stencil films and sundry equipment and materials.

Index

Page numbers in italics refer to illustrations